Bradley Beach
Treasures

Bradley Beach
Treasures

Reflections of the Jersey Shore

BETTE BLUM

Charleston · London

History
PRESS

Published by The History Press
Charleston, SC 29403
www.historypress.net

Front cover: *Left to right*: Shirley Gordon, Mary Lewis and Anne Schenkel. *Author's collection.*
Back cover, top: Bradley Beach postcard with familiar landmarks. *Author's collection.*
Back cover, bottom: Dolphin Fountain, a Bradley Beach landmark for decades. *Photo by Sam Ballen.*

First published 2007

Manufactured in the United Kingdom

ISBN 978.1.59629.299.4

Library of Congress Cataloging-in-Publication Data

Bradley Beach treasures : reflections of the Jersey Shore / [edited by] Bette Blum.
 p. cm.
 ISBN-13: 978-1-59629-299-4 (alk. paper)
 1. Bradley Beach (N.J.)--History--Anecdotes. 2. Bradley Beach (N.J.)--Social life and customs--Anecdotes. 3. Seaside resorts--New Jersy--Bradley Beach--History--Anecdotes. 4. Summer resorts--New Jersey--Bradley Beach--History--Anecdotes. I. Blum, Bette.
 F144.B64B73 2007
 974.9'46--dc22

2007017133

Notice: The information in this book is true and complete to the best of our knowledge. It is offered without guarantee on the part of the author or The History Press. The author and The History Press disclaim all liability in connection with the use of this book.

Contents

Acknowledgements 9
History 10
Introduction 13

Part One: Family and Friends

Our Home Away from Home, by Ruth Rubenstein 16
Unforgettable, by Lori Dinnerman Dubin 17
Maidie's Memories, by Maidie Schwartz 22
Howie Sprechman, by Linda B. Sprechman Jacobson 24
Milt and Ethel, by Milton Schoenberger 27
Memories So Dear, by Frances Bank 27
A Day at the Beach, by Bette Blum, as told by Esther Goldman Stein
 and Ben Goldman 29
A Family History, by Michael Alper 31
Moving Out, by Debby Greenstein 39
Bradley Since 1917, by Carole Levine Rothman 40
Summers at the Shore, by Nathan Jacobson 42
The Sea Cliff Hotel (1920–1932), by Elenore G. Peckerman 47
Bradley Beach Roots, by Phyllis Reich 48

CONTENTS

Bradley in the 1950s, by Elaine Yelner 49

My Wonderful Memories of Bradley Beach, by Sandy Kaston 51

My Mother Rita, by Rich Weissman 55

Cliff Villa, by Tim Tsang 56

Teach Your Children Well, by Ronnie Bornstein-Walerzak 58

Jeff, the Bradley Beach Lifeguard, by Jeff York 60

Father's Day, by Bette Blum 63

Virgil's, by Bette Blum, as told by Rose, Sal and Maryann Galassetti 65

Joel, by Naomi Bornstein Axelrod 70

Me and My "Grampa" Joe, by Marc Alan Schwartz 73

True Love, by Florence Silverman Berman 74

Boy, Do I Miss Those Days, by Lila Barsky 76

A Lasting Friendship, by Gladys Gordon Blum 76

Marty, by Rich Weissman 77

LaReine Hotel Pool, by Ron Rosen 78

Growing up in Bradley Beach, by Skipp Silverman 80

A State of Mind, by Marge Tsang 81

Part Two: Fun and Games

Pinball Fever Thirty Years Later, by Karen Usatine 84

Love at First Sight, by Barbara Wigler Dinnerman 86

My Memories of Bradley Beach, by Richard Roth 88

Echo of a Summer Night, by Mark Jacobs 89

Bradley Beach Childhood, by Charlotte Lowitz Tucker 90

Summer Lovin', by Ronnie Bornstein-Walerzak 91

I Remember When, by Gladys Gordon Blum 92

Bradley Beach Sand in My Shoes, by Beth Levine Klee 95

Wonderful Memories, by Pam Cohen Luks 97

The Best Times, by Amy Weinstein Montuori 97

Hooked for Life, by Richard Schwartz 99

Bradley Beach Treats, by Phyllis Fischman 103

I'm Looking for Jay, by Rich Weissman 103

The Bradley Beach Experience, by Rheda Sulzman 105

Mrs. Radner's Boardinghouse, by Judy Schlosser 105

Popsicles, by Muriel Katchen Reid 106

CONTENTS

Fond Memories, by Barbara Brooks Kimmel 107

Truly a Bradley Beach Baby, by Marc Alan Schwartz 109

Days and Nights in Bradley Beach, by Bette Blum, as told by Jerry Bieler 111

One Memorable Summer, by Maxine Cohen Glazer 113

The Eric House and Beyond, by Bette Blum, as told by Ida Tepper Zagnit 114

Learning to Drive in Bradley Beach, by Marc Alan Schwartz 115

Lots of Good Memories, by Barry Goldberg 117

Part Three: Sea Glass and Driftwood

Bradley Beach Then and Now, by Gladys Gordon Blum 120

Bradley Beach History, by Shirley Ayres 121

Swimming the Jetties, by Robert E. Drury 124

September Rescue at Sea, by Muriel Katchen Reid 124

Fish Story, by Sandy Kaston 125

The Junior Lifeguard, by Bruce Kreeger 126

The Local, by Bryan Feinberg 128

Some of My Memories, by Michael P. Schneider 130

Incident at Bradley Beach, by Dennis Dubin 131

Finest Memories of Bradley Beach, by Arline Cohen 134

The 1940s, by Stephen Weiss 135

Ode to a Knish, by Lori Lafer Litel 136

Got Your Badge?, by Sol Seigel 136

My Mom, the Badge Lady, by David Schechner 139

Why Bruce?, by Richard Schwartz 140

Splinters, by Elenore G. Peckerman and Elsa L. Cook 141

Bradley Beach Forever Etched in My Memory, by Karen Usatine 141

Trip to the Beach, by Ronnie Bornstein-Walerzak 142

My Mile of America, by Bette Blum 143

Part Four: The Reunion

Blankets, Ices and Shaving Cream, by Bette Blum 148

Back to the Beach, by Kitty Bean Yancey 152

About the Author

 159

This book is dedicated, with love, to my parents and grandparents, who brought my sister Janet and me to Bradley Beach every summer and made us two of the luckiest kids in the world.

To my wonderful Bradley Beach friends, my dear friends for life.

For Sam and Sara—enjoy Bradley Beach forever!

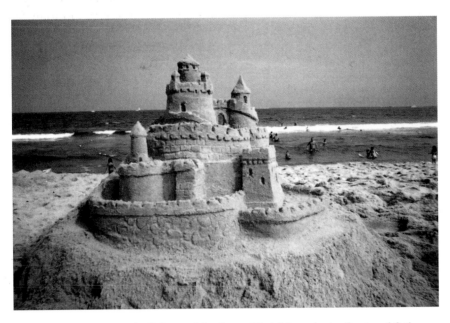

Bradley Beach sand castle by Rebecca, Jake, Joe and Josh Mermelstein. *Courtesy of Cathy Mermelstein.*

Acknowledgements

Everlasting appreciation to all who contributed stories, poems, photos and memorabilia for this book's priceless account of a special seaside town. Special thanks to Shirley Ayres, Bradley Beach borough historian, for her input, interest, guidance and fabulous memorabilia; Rich Weissman for his many hours of collecting stories and gathering memories; Sharon Allen Jarchin for her helpful words of wisdom; Out-House Advertising, Inc. in Fort Lauderdale, Florida, for the use of their studio, especially Rick Sparkes for his design and Matt Johnson for his photography, design and patience; Sam Ballen and Fish Fosh Studios; Arlene Hyland-Geraghty, my literary advisor, for her direction and faith in this book; Joyce Marie Taylor for her invaluable expertise and advice; John Daniels for his superb editing; Jerry Skolnick for his editorial input; and Leslie Kaston and Alan Gordon for their contributions of priceless memorabilia. Gratitude to all of my friends and family for their encouragement and patience.

History

L egend has it that back in 1679 Captain William Kidd anchored his vessel off Duck Creek, now known as Sylvan Lake, in Bradley Beach, New Jersey. It is said that he stayed in Bradley Beach and buried his treasures between two pine trees on Brinley Avenue.

Almost two hundred years later, William B. Bradner and James A. Bradley purchased land north of Avon. The land was part of Ocean Township and was named Ocean Park at that time. Since the name was too similar to a surrounding town, it was suggested by the post office to change the name. William Bradner then named the town Bradley Beach after James A. Bradley, who also happened to be the founder of Asbury Park.

In March of 1893, Bradley Beach was incorporated as a Monmouth County municipality. Soon after, the Bradley Beach Fire Company was organized.

The early 1900s brought the new First Methodist Church, Schwarz Drugs, the Church of the Ascension, Bradley Beach Borough Hall, the firehouse for Bradley Fire Company No. 3 and the St. James Episcopal Church.

Bradley Beach became a very popular resort town by the mid-1920s and attracted several visitors from New York, Pennsylvania and Newark, New Jersey. There were many stores, two swimming pools, hot water baths and of course, a beautiful beach. In the late 1920s, Congregation Agudath Achim was established and the Bradley Beach Public Library was dedicated. The Bradley Beach First Aid Squad was created in 1933 and during the early 1940s the Magen David Congregation became the orthodox synagogue for Sephardic Jews from Brooklyn.

Bradley Beach. *Photo by Sam Ballen.*

A landmark was established in 1947 when Vic's bar and restaurant opened for business. It remains today as one of the most popular restaurants along the Jersey Shore.

In the 1950s the Garden State Parkway was completed, which brought more and more summer and year-round residents to Bradley Beach.

Bradley Beach celebrated its sixtieth anniversary in 1953 with a "Diamond Jubilee Celebration" and began its annual Baby Parade. The same year, the Veterans Memorial Field was dedicated. During the late 1950s the new Borough Hall and Bradley Lanes opened and Master's Bakery at Main and Brinley became another landmark for several decades. In 1965 Piancone's Specialty Shoppe opened, and in 1968 the Annual Easter Parade began.

Sadly, in 1974, the popular LaReine Hotel at LaReine and Ocean Avenues burned to the ground.

The 1970s also brought the Bradley Beach Youth Athletic Club, Piancone's Pizzeria and Barry's Tavern. Also, the American Freedom Train exhibit came to town in 1976.

Celebrities including Jack Nicholson, Danny DeVito, Cesar Romero, Bruce Springsteen and Philip Roth all spent much of their time growing up in Bradley Beach.

The current population of Bradley Beach consists of over five thousand year-round residents and soars to thirty thousand during the summer months. Today's residents and visitors alike can enjoy a beautiful expanded beach—thanks to the U.S. Army Corps of Engineers—Fletcher Lake to the north and Sylvan Lake to the south, a boardwalk, bocce ball courts, numerous fine dining establishments—including bakeries and coffee shops—miniature golf, surfing, fishing, summer concerts and dances.

I hear that Captain Kidd never returned to reclaim his treasure. Some say the treasure never existed and some say it drifted to the sea, but lucky for us, we've all uncovered a bit of treasure in our lifetime throughout the years in Bradley Beach.

Introduction

For generations, families flocked to the Jersey Shore to experience summers away from the city, filled with days of warm beaches and nights of amusements, dancing, concerts, walks on the boardwalk, miniature golf and, most importantly, good old family bonding, day in and day out. Some folks were even lucky enough to spend the entire year at the shore, making it their permanent home.

Every town at the Jersey Shore has its own personality, mix of people, landscape and landmarks, making each one truly unique. At the shore, one could find the best Italian food, steamers, pubs, bars, waterfront restaurants and hip coffee houses; fly kites and watch the seagulls fly; fish in lakes, inlets or the ocean; walk the great boardwalks filled with salt water taffy, fudge, candy apples, custard, cotton candy, pizza, snow cones, hot dogs and funnel cakes; spend time at the Penny Arcade and on rides; build the most beautiful sand castles; and make the best friends.

I was fortunate to spend my summers in Bradley Beach, a mile-long town right in the middle of Avon-by-the-Sea and Ocean Grove, a mile south of Asbury Park. Growing up in Bradley Beach, our special mile of America, left us all with a feeling of belonging and fitting in to this simple world where we all lived, loved and appreciated life. My grandparents, Shirley and David Gordon, bought a bungalow on Madison Avenue in 1937. In 1957, right after I was born, my parents, Gladys and Louis Blum, bought the bungalow from them and my grandparents purchased the house next door on Ocean Park Avenue.

The summers in Bradley Beach turned into some of the best days and best times of my life. Spending time with your family, getting to know the

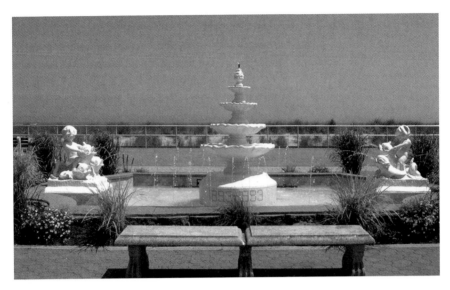

Dolphin Fountain, a Bradley Beach landmark for decades. *Photo by Sam Ballen.*

families next door and across the street and making best friends for life were all part of a priceless bonus you received, summer after summer. I later moved to south Florida to live near the beach all year. It is certainly wonderful, and a paradise of its own; however, a big piece of my heart still remains in Bradley Beach.

In 2004, I put together a reunion of sixty Bradley Beach friends and their spouses who spent time together in the early 1970s as teens growing up and enjoying the shore. We came from seven states to reminisce and see each other once again. It brought us back to a special and memorable time in our lives. Then it became time to record and pass on the wonderful stories and memories from generation to generation of a time at the shore when it was almost a perfect world.

In Bradley Beach, folks from several ethnic and economic backgrounds lived side by side as neighbors and friends. Years later, many are busy renovating their homes, enjoying the beach and passing on the safe and natural feeling of the Jersey Shore to future generations. Not only do I treasure the moments I spent there and the time I can go back each year, but I've found that others who have spent time, along the way, in this special town display a nostalgic burst of excitement when telling their own stories and experiences of Bradley Beach.

Enjoy the collection of stories, memorabilia, photos and postcards from several folks who were also lucky enough to live "Once Upon a Time" in a special little seaside town at the Jersey Shore called Bradley Beach.

Part One:

Family and Friends

Our Home Away from Home

By Ruth Rubenstein

Where do I begin? Those were the days, my friend! We hoped they'd never end!

Bradley was our "home away from home" and was the place to be as a teen. From the age of five until I was married with children of my own, it was our place. My parents owned a home on secluded Monmouth Avenue, across from Sylvan Lake facing Avon-by-the-Sea, on which swans and chicks made their home. This gave my dad the opportunity to feed them when he returned to Bradley after a long work week at his dental office.

Our street had barely any traffic at that time, except for the vegetable man who rang his bell in front of our house to alert us that it was time to stock up on produce. The next salesman was Dugan's driver, who inquired if we needed cake or bread. Since our street consisted of only five homes, we all played together as kids. Many of our friendships are still intact.

As teenagers we could release energy swimming in the blue, clean ocean, sunning on the wide, white beach, riding a bike on the boardwalk or going to the arcade or the pavilion to meet our friends. It was a carefree time for us. I remember the umbrella boys on the beach—college kids trying to make a few bucks, waiting for a customer who needed a beach chair or an umbrella to enjoy the day.

At the top of the Second Avenue entrance to the beach stood the refreshment stand where penny candy such as Mary Janes, Tootsie Rolls,

Tootsie Pops or Mellow Roll ice cream were sold. Next to the refreshment stand sat an elderly summer policeman checking badges in order for us to descend to "paradise." Children did not need a badge until age fourteen and we thought the badge made us all adults!

I remember Rudy was the head of lifeguards on the beach there. He became a surrogate father to my sister and me, teaching me to swim and not fear the ocean. We were often permitted to sit atop the high white lifeguard chair, whistle in hand, ready to save someone, with Rudy standing guard beside us.

If a deep tan was your desire, baby oil and iodine were the choices. If blonde hair was desired, lemon juice or vinegar was the thing! A few broiling hours in the sun—voila you were now a gorgeous blonde!

Saturday night was party time for adults and it was dress up time. Not like now, with the torn t-shirts and old jeans. It was all glitz and glamour. Hair done just right, long gowns, jewelry and all done to perfection. And men never went out on Saturday night without the white shoes, white pants, blue blazer, tie and fancy shirt when walking with their lady.

My friends and I found the best fries and hot dogs at Mike & Lou's on Ocean Avenue. The arcade across from the dance pavilion on the boardwalk gave us the opportunity to try our skill at skeeball or the penny machines. Farther down the boardwalk on Newark Avenue was the bingo parlor where my mom spent many an evening trying to win a quarter or two. We also spent many evenings at the pavilion on McCabe Avenue listening to the latest gossip and discussing the current singing idol, who was, of course, Frank Sinatra!

For me, Bradley was the town where I grew up and spent my youth. Even though it was a dangerous period, as it was wartime, the '40s and '50s were a great time to be young. This was life during Bradley's heyday.

Paradise is never lost. We carry it forever in our memory.

Bradley—may it reign forever!

UNFORGETTABLE

By Lori Dinnerman Dubin

I spent every summer from the late 1950s to the mid-1970s in this idyllic world of sand, surf, sun and fun. I transformed from a child to a young adult during those summers and I am the person I am today because of my experiences in Bradley Beach.

My earliest memories of Bradley Beach begin when I was around four years old. My mother and I had just made the long journey down the Garden

Bradley Beach postcard with familiar landmarks. *Author's collection.*

State Parkway and arrived at "Aunt" Bea's boardinghouse on McCabe Avenue. Of course those were the days prior to air-conditioned cars; so as I climbed out of my mom's 1950s Plymouth, I remember complaining, "I'm hot!" At that moment an adorable little boy popped up out of nowhere and said, "Nice to meet you, Hot, I'm Larry!" It turned out that his family was staying at the same boardinghouse and Larry and I became friends. He taught me that people came in all shapes and sizes. Although Larry was a dwarf, he did not let his condition handicap him. We played together on the beach for many summers to come.

My mom and I spent several summers sharing a room at "Aunt" Bea's. Then came the very special summer of 1962. I was almost seven years old and had spent many years living with my divorced mother and grandparents. Mom had dated a lot of guys and was even engaged a couple of times, but that summer our lives changed forever! One day a very handsome, very tan man arrived on the beach accompanied by a very pretty, very tan woman. My mom commented, "Those two make a beautiful couple!" A friend informed her that they were not a couple, but were actually brother and sister. Mom was introduced to them, and I believe it was love at first sight. Observing their whirlwind courtship through my seven-year-old eyes, I was anxious for Mom to make this man my dad! My wishes came true a few months later and thus began a new chapter of our Bradley Beach summers.

We outgrew "Aunt" Bea's boardinghouse and my parents rented a back bungalow on McCabe Avenue, just two houses from Ocean Avenue. Our little house had two bedrooms, a living room, a full kitchen and a bathroom with an indoor shower! We even had a porch and a fenced yard for our poodle, Kippy. This bungalow became our summer home for the remainder of our stays in Bradley Beach. We had so much fun…friends and family would visit all the time and everyone knew that the skeleton key to the front door was in the mailbox, so we didn't have to be home when they arrived. My grandparents, who had spent many summers in Bradley Beach when my mother was a child, used to spend time there too. My dad used to work in the "city" and drive down the shore for the weekends, as so many of the fathers of my friends did. During the week, the beaches were filled with women and children. On the weekends, it was family time. I used to love watching the grown-ups dance at the pavilion on the boardwalk. We had our own kids' dances at the Newark Avenue pavilion, but they never seemed quite as much fun.

The highlight of my childhood summers was the Penny Arcade! There were many games where we could win tickets. The goal was to save them all summer and get an amazing prize. As sad as I was that summer was ending, I couldn't wait to cash in my tickets for a gigantic stuffed animal or special doll. At least once a week we would walk to Asbury Park to go on the rides and play games in the arcades. As I grew older, the ticket games in the arcade lost their appeal, but were replaced by my favorite pastime—pinball! Yes, I liked to think of myself as a pinball wizard, especially on a machine called Ding Dong.

I used to share flippers with my good friend Bart and we would spend hours trying to beat our own records and win free games. I can still feel his shoulder against mine as we partnered up to play. The allure of Asbury Park changed for me too. Rather than rides, I became attracted to the concerts and I saw some great ones during my teenage years, including the Doors, Iron Butterfly, Emerson, Lake & Palmer, Yes, the Eagles and of course an unknown Bruce Springsteen at Upstage and the Stone Pony!

Speaking of Bart, we lived across the street from each other in Newark as toddlers, both moved to Livingston in the 1960s and our families spent every summer in Bradley Beach. In fact, his mom was the friend who introduced my parents. If I had to pick one person who most influenced my adolescence, it would be Bart. Having grown up without siblings, he became my surrogate brother. The summer of 1968 began my odyssey into the world of teens. For me Bradley Beach was the New Jersey version of *Where the Boys Are*. Through my friendship with Bart, I met my first boyfriend. We were a great threesome as we spent the glorious summer months together. We experienced our first flashes of freedom as we started going to the beach and boardwalk without our parents as chaperones.

Concert tickets. *Author's collection, photo by Matt Johnson.*

The following year was the amazing summer of 1969. While the world marveled at Neil Armstrong walking on the moon, followed by the Woodstock festival of rock 'n' roll, sex and drugs, I was almost fourteen years old, hanging with my friends at the mini-golf course on the boardwalk. There was a nice elderly couple who owned the venue and they took a liking to us and let us play all the miniature golf we could for free, as long as we helped them out with small chores around the golf course. A new hangout was born! That summer we were hundreds of miles from Woodstock, but the spirit was there as we sat in the golf clubhouse and listened to psychedelic music and radio announcements of traffic jams. We longed to be there, but Bradley Beach was our Woodstock and we made the best of it.

Ticket from *Woodstock* movie. *Author's collection.*

The summer of 1970 brought the *Woodstock* movie and soundtrack, as well as a true coming of age to my group of friends. Our horizons and minds expanded, our numbers grew and we spent a lot of time enjoying each other and ourselves. We were right smack in the middle of the hippie movement and war protests, but we did our own thing all summer long. Days were spent on the beach, nights on the boardwalk. Even though the world was quickly changing, we repeated the same rituals we had performed every summer before.

The next few summers flew by very quickly...there was so much happening to me personally and to the world around me. For a while my friends and I were actually too cool to hang out in the sun on the beach. We took up daytime residence under the boardwalk! No, we were not making out like the Drifters' song implies (at least not all the time). We just enjoyed being different! Music became even more important to us and we spent many days and nights listening to the Who's rock opera *Tommy*. It was practically our anthem. Summer romances blossomed and withered while friendships formed and grew in a way none of us had ever experienced before. We spent our summers in a paradise away from our hometowns, away from schools and responsibilities. Like the ebb and flow of the Atlantic Ocean tides, we grew away from mom and dad while developing an existence of our own.

During the summer before my high school senior year, I was much more on my own in Bradley Beach. Many of my friends had discovered that some of the local boardinghouses were very teenager friendly and many of us sought refuge in them. The party scene shifted away from the boardwalk and away from our parents' watchful eyes. My refuge was called the Janet House. It was known for its liberal attitudes and great parties. There was always something happening on the top floor.

After I graduated from high school in 1973, my parents stopped renting the bungalow on McCabe, as their interests had shifted to golf and tennis clubs. They were happy with day trips to the shore. This left me with the opportunity to spend a lot of weekends at the Janet House. I knew that I would be going off to college and my summers would never be the same. I enjoyed every waking moment of that last summer, making sure that I slept as little as possible and watched every sunrise over the ocean that I could. My close-knit group of shore friends was beginning to scatter and I knew the glory days would soon end. What I did not know was the impact that my Bradley Beach experiences would have on me for all the years to come.

I always assumed that my children would spend lots of time in Bradley Beach. I would marry someone, rent or own a shore house and spend every summer there with all my friends and family. What a dream that was! In 1979 my husband Dennis and I moved to Florida, the land of endless summers. Before we left New Jersey, we made a special trip to say goodbye to the shore. I really thought that I would still bring my children to Bradley every year, but that never happened. In fact, it was ten years before I saw Bradley Beach again. With my two children, ages seven and four, in tow, I searched for the Bradley Beach I knew. So many things were gone...the Penny Arcade, the dance pavilions, the large beaches, the boardwalk restaurants, the Janet House! I did not see one familiar face. This was not MY Bradley Beach. Then I turned the corner onto McCabe Avenue and there was our bungalow. As tears filled my eyes, I realized that what really mattered was not the present, but the past. Landmarks can be removed, but my memories are there forever. I will always treasure them and cherish the opportunity to share them with others.

Maidie's Memories

By Maidie Schwartz

Bradley Beach. I summered in Bradley as early as seventy-eight years ago. There were elegant hotels at that time. My parents took me to the Zins Hotel at age three months. Guests were required to dress very formally and no one was allowed on the boardwalk without a coverup. Men even wore tops at all times. Saturday nights saw furs and sometimes gowns along the boardwalk and at the hotels. In the early 1940s there were pony rides for the children near Newark Avenue beach and often my grandparents awaited the fishing boats at Park Place beach to purchase fresh fish.

When the LaReine Hotel merged with the Bradley Hotel our family circle from the Newark area held its annual outing there. Syd's, a hot dog

Steven, *left*, and Elliot Schwartz, enjoying the rides at Park Place in 1955. *Courtesy of Maidie Schwartz.*

restaurant from Chancellor Avenue, Newark, opened a shop in the hotel across from the beach and stayed until a hurricane forced him to move to Allenhurst. In 1957, the same year that Gladys and Lou Blum (Bette's parents) bought their house on Madison Avenue, my husband Bert and I bought a bungalow a block away. We were classmates of Gladys from Weequahic High School. Our sons Elliot, Steven, Marc and Richard were neighbors and friends of Bette and her sister Janet. Once our children were grown, Bert and I lived in Bradley all year round on the south end of Madison Avenue before relocating to Florida.

Do you remember the pool where swimming was taught and swim meets were held? People watched the meets from a balcony above the pool. Downstairs there was a place for our elders to have hot saltwater

baths. (Does the word spa come to mind?) When the swim meets ended we adjourned to the Kohr's soft ice cream stand. Across from the ice cream stand was a pavilion where dances were held every Wednesday night.

During the years of the '40s to the '70s rooming houses flourished. Families sometimes rented one large room per family in a large house. They shared a bathroom as well as a shelf in a refrigerator. How they kept track of the food in the refrigerator is anybody's guess. Some folks left spacious homes to spend the summers at the shore. It was a defense mechanism to avoid the five-hour drive before the Garden State Parkway was built. Huge houses such as the Janet House and the Milton Lodge spawned many marriages. As Imogene Coca would say, "Isn't it a small world?"

Our routine then was to take the children to the beach in the morning, return after lunch and then walk to the boardwalk to the kiddie rides. No one had a second car, so we all walked. Many friendships have endured these many years because of our summers. I especially have retained my relationship with Gladys and with Cele Pontecorvo, neé Dagostino. Cele's mother was a cook for her aunt, who owned Mom's Kitchen, and we shared many memories with our combined broods of four children each.

Bradley Beach sand is in all of our shoes.

HOWIE SPRECHMAN

By Linda B. Sprechman Jacobson

My husband, Howard "Howie" Martin Sprechman, came to Chicago (from Passaic, New Jersey) on a business trip in October of 1965 and never returned to New Jersey, except to visit. We fell in love and I had to stay in Chicago to finish school, so Howie quit his job so we could be together and we bought a home in Chicago.

Howie worked his entire life in Chicago in the television industry. After getting out of the USAF, he returned to New Jersey and studied television. He graduated from the RCA Institute in New York City and spent a couple of years at Farleigh Dickinson; TV was his passion.

He worked at WGN-TV in Chicago as senior sports and news cameraman, on the camera crews for the Chicago Cubs, Chicago Bears, Chicago White Sox and the Chicago Blackhawks broadcasts. He operated the famous "replay" camera, as he was the best! In his spare time, he was an adjunct professor at Columbia College in Chicago, in the TV and Media Department. His photo hangs in the rotunda there. He was beloved by his students and wanted to share his love of TV with them; it was a mutual admiration and respect.

Howie also worked as lead camera on the *Phil Donohue Show* for nine years, while *Phil* taped out of Chicago. In fact, he was in the studio when Phil met Marlo Thomas. Howie and Phil had played racquetball together. In 1979, when the pope came to Chicago from Rome, Howie made local headlines as the only TV person with FBI, CIA and Secret Service clearance and was therefore permitted to be "an arm's length" from the pope.

I only mention some of his background to let you see that Howie (and I) had an exciting life. He loved his job, he loved mingling with celebrities and he always said that he would do this job as long as he lived, even for no pay if necessary, because he loved going to work each day that much!

The only thing he loved more was his family. "His girls" were absolutely the most important thing to him, and I was a close runner-up. Howie was well known in Chicago, and his death brought news stories on every TV channel and radio station in Chicago. The *Chicago Tribune* devoted a large article to Howie when he died. Over a thousand people, many of them celebrities, attended his funeral and his shiva.

But regardless of the years in Chicago, of his successes there, there was one thing that Howie always longed for: Bradley Beach.

I am a native Chicagoan. We were introduced his first week in Chicago, and we got engaged on our first date and married in August 1966 as I began my senior year of college. Howie always shared "Bradley and Belmar Stories" with people he met in Chicago, and when his old New Jersey friends visited us, they spent hours sharing old stories and fond memories of the Jersey Shore.

As one used to Lake Michigan, a beautiful shoreline, I could never understand his devotion and commitment to Belmar and Bradley until the fall of 1987, when after a long illness (cancer), Howie realized the end was near (he was going in for a bone marrow transplant in December) and wanted to see his beloved Jersey Shore one more time. In November of 1987, despite his obvious weakness and pain, we flew to Newark and drove to Howie's sister's home in West Long Branch. From there, the next day, we set out for Bradley Beach.

It was a cold, windy day, but Howie didn't seem to notice. He kept his eyes peeled for the beach and told me and our two daughters (Marni and Sandi) about how he had introduced his sister Sheila to her husband, Bill, at Bradley Beach. He told us of how he made lifelong friends there, one being Bob, the best man at our wedding twenty-one years before, a friend who had come to Long Branch the night before to see his old buddy. Other pals, also introduced at Bradley Beach—Hank, Steve, Danny and Sheila—had kept in touch all these years, even though many had left the New Jersey area long before.

Howie's mom, Etta Plotkin Sprechman, with Howie on right and cousins. *Courtesy of Linda B. Sprechman Jacobson.*

Howie's stories kept us mesmerized, as usual, and we hung onto his every word, knowing that he would likely not be able to tell us his stories again. Once we arrived at the beach, he pulled his hood over his head and asked us to follow him. He described what he used to see and experience. He said that as a little boy he especially loved playing in the sand "there" with a pail and shovel, and built things in the sand that made him proud. As a teenager, he always went to the beach to pick up girls (he was very handsome and I'm sure had no trouble in that department!) and of course, to show off his physical prowess by ball throwing and other activities on the beach. He related that it was the one spot on earth where he had only wonderful memories, and he would love to go back to that carefree time.

He stood silently for several minutes, overlooking the waves lapping at the sand, turned around to me and his daughters and said, "After I am gone, if you want to see me, just come out to Bradley Beach in the summer, and I will be the little boy in the sand with the pail and the shovel."

Milt and Ethel

By Milton Schoenberger

It was July Fourth weekend in 1947, and I was sitting on a blanket in Bradley Beach, I think it was McCabe Avenue, when a familiar face walked by. It was a lovely girl who I had briefly met at the Irvington YMHA (Young Men's Hebrew Association) in 1946. She stopped to chat and we decided to meet that evening. We stopped for a bite at Mike & Lou's and I really fell for her hook, line and sinker.

I didn't have a car and I had come down on the train. Ethel had gotten a ride from a male friend but decided to ride the train to Newark. Her dad picked us up and drove me home. That started our courtship. Ethel lived in Maplewood Village and I lived on Huntington Terrace, which was a two-bus and 1½-hour trip if I was lucky. We married on October 28, 1950, the day after her twentieth birthday. I was twenty-one. We will be celebrating our fifty-sixth anniversary this year.

Would we have ever met if the lure of Bradley Beach had not brought us together?

Memories So Dear

By Frances Bank

Being a teen in the '50s, such happy years,
Spending summers in Bradley with family and peers.

205 LaReine was my home away from home,
No air-conditioning, TV, microwave or phone!

It was a boardinghouse, tenants had to share,
The kitchen, dining room and shower in the rear.

We all lived together in harmony and grace,
It didn't occur to us to "need our own space."

We met at Mike & Lou's, Doc's or Syd's,
Especially Saturday nights, there were hundreds of kids.

Miniature golf and the Penny Arcade,
Our favorite pastimes, we sure had it made.

No computer games or expensive toys,
Stickball was played by the cute Jersey boys.

As girls we'd cheer and then go to eat,
Vic's pizza was (and still is) a delectable treat.

We didn't know that it shouldn't be done,
And spent hours on Brinley, basking in the sun.

When the ocean was rough and we wanted to be cool,
We would go for a swim in the McCabe Avenue pool.

We felt safe and stayed out late after dark,
And walked through Ocean Grove straight to Asbury Park.

Where did we go when we had bad rain?
To the Palace Theatre, right up on Main.

We didn't drive cars but we made no fuss,
We just hopped aboard a double-decker bus.

The friends I made I still love and see,
One even became a husband to me!

We never talk politics, religion or war,
And love reminiscing about our fun at the shore.

All the kids of today spend their summer days,
On cruises, at Disney World and long sleep-aways.

But I know that nothing can ever compare,
To Bradley Beach summers and memories so dear.

A Day at the Beach

By Bette Blum, as told by Esther Goldman Stein and Ben Goldman
It was a sunny beach day. The water was calm and warm and the air was just right. It was October though, and not the Jersey Shore. It was on the beach of Hallandale, Florida, where memories were shared and good times in Bradley Beach were once again told.

Leon Goldman came to the United States from Poland in the late 1920s. In 1929 he sent for his wife Gussie and their son Ben, who also emigrated from Poland. Here, in the United States, they had a daughter, Esther, to complete their family. They soon became the owners of the Sea Gardens, once owned by the Fleischmanns, who were part of the yeast and gin empire.

The Sea Gardens was a strictly kosher hotel that once stood at 1201 Ocean Avenue, directly across from the beach near Cliff Avenue. Every day except Friday, the Goldmans would get their fresh, hot rolls straight from Master's Bakery on Main Street. On Fridays, before the Sabbath, Gussie would bake fresh challah for her family and all of her guests to enjoy.

Leon and Gussie often sponsored people who came to America from Poland for a better life. Some folks even ended up staying at the Sea Gardens and working at the hotel, as that's the way the Goldmans were. One young couple, Batia and Sigmund Borkowski, who were brought to America by the church lived and worked at the hotel. When they had a child they even named her Esther as an honor to the Goldmans. ·

Esther and her older brother Ben would always be busy working at the Sea Gardens in the dining room, as chamber maids and as hosts. Later in the evening, about 10:00 p.m., when dinner was over, their work was done and they could get away, Esther and Ben used to walk down the boardwalk to their special spot on the beach, on top of a flat box where garbage cans from the beach were once stored. They would sit there, across from the LaReine Hotel, watching the fancy folks stroll down the boardwalk, "dressed to impress," as it was in those days. Esther also recalled her dad, Leon, going to Jane Logan's every afternoon for his special treat: a banana split with all the toppings.

The backyard of the Sea Gardens bloomed with roses all summer long. The Goldmans often held dances in their backyard. One summer evening at one of the dances a young lady named Marilyn stood right in the garden and caught Ben's eye. He found her very interesting and attractive.

Some things are meant to be. With a little help from his sister Esther, Marilyn began to go out with Ben. Their love then bloomed like the roses in the garden. They were married in 1951 and had three children: Debra,

The Sea
Garden
Hotel.
*Courtesy
of Esther
Goldman Stein.*

Susan and Karen. For a time they lived in Bradley. Ben had a newspaper distribution business on Main Street, distributing the *Asbury Park Press* and the *Newark Evening News*. When their daughter Debra was a baby, she even won a prize at the annual baby parade, which was held on the boardwalk in Bradley each year.

Esther, a shy young lady, was always called upon by her parents to do errands. One summer day, Esther had to go to S & S (Morris Shapiro and Mendel Shapiro's grocery store) to buy some bagels. When she went to pay, the young man behind the counter asked her name before he handed her the bag. She hesitated and then replied, "Esther." He then went on to ask where she bathed and if he could join her in the afternoon. Esther was bothered and reluctant to reply. She returned home, complaining to her mother, who told her to be kind to the young man and open her eyes.

Esther continued to go to Brinley Avenue beach day after day with her friend Roz Wurtzel and saw the young man from S & S. She not only opened her eyes but opened her heart and in 1952 Esther Goldman and Irving "Skip" Stein were married.

They had three children, Steven, Joanne and Risa, who were also able to enjoy Bradley Beach and times with their grandparents at the Sea Gardens. Esther even saved a letter her daughter Joanne wrote to her in August 1977 describing her recollection of the days at Bradley Beach. Joanne described her journey back through summers at Bradley Beach as she "passed through the past" and shared wonderful memories at the beach, a peaceful time, the lunches her grandmother made for her and even Virgil behind the counter of his lively store.

The simple times, family times and good times in Bradley may be a part of the past but are forever passing through our hearts. That was Bradley Beach. Bradley Beach was heaven.

It may still be.

A FAMILY HISTORY

By Michael Alper

Like my parents before me, I too was to partake of the summer pleasures and pleasantries of Bradley Beach. Both my parents had grown up as first-generation Jewish Americans in Newark, New Jersey, and, as most of their contemporaries did during those hot summer days before air conditioning, they flocked to summer residences and rentals "down the shore," meaning Bradley Beach. By 1930 my father's family had already established itself in a summer residence in the persona of my father's oldest brother, Jerome Alper, who purchased an elegant old Victorian structure at 415 Second Avenue. My mother's family, Al and Eva Sofman, got lucky in 1936 when they were given their summer residence, a plain old clapboard on one of the closest streets to Bradley, in Neptune.

Both families were to use their summer homes frequently during the summers leading up to and including the war years. Playing host to the extended families was both an honor and a curse. My grandfather loved it because it gave him the opportunity to hold court where his advice was dispensed like quarters at the 21 table. For my grandmother, it was sheer drudgery cleaning up after everyone. My grandfather once told me that even those with businesses in the city, come Friday afternoon, 2:00 p.m., would be quitting time—time to go home and load up the family car (or board that Central Jersey Coast Line) and make that several-hour trip (no

Garden State Parkway then, and Route 9 was a two-lane dirt and gravel roadway meandering all the way down to Atlantic City and Cape May cutting straight through the hearts of all those Jersey Shore towns). People like Mr. Bleemer, the butcher, Mr. Shapiro, of S & S groceries, and so on eventually established Jersey Shore branches at Bradley Beach for their Newark-based businesses.

My first dalliance with Bradley Beach was to come during the late summer of 1959, when my parents decided to join with my grandparents and rent a two-family apartment house on the corner of Ocean and Fourth Avenues from a Mr. Thompson, with whom my father stayed up all one evening just to get the rent reduced by twenty dollars. I had just turned five, when all of a sudden I discovered that more of my family was down for the summer and staying at their Bradley residences and so we would visit with them often.

We would go for a visit with Uncle Jerome at his house, but we would go to the beach with cousins Rita, Marty, Larry and Rich, "Uncle" Morey, Aunt Bert and their friends the Estersohns and the Fishmans. In fact, it was during this time that all the families began sitting together on the beach between Fourth and Fifth Avenues. They would all line up the chairs in a row like soldiers in a platoon while my cousins and friends would frolic in the incoming surf.

After the summer ended, we all went home to our other lives, but I guess that my dad couldn't get the summer out of his life because the following summer he took me and my mom to the beach one day, and when he returned to get us, he said, "Guess what?! I bought us a summer house here in Bradley!" We went to look at the house—506 Third Avenue—and I thought to myself, "What a mess!" The home was a pre–World War I stucco and wood-framed three-story house, yellow in color, rather imposing with a second-floor front balcony off both front bedrooms, a long driveway and detached garage. It was built on a sloping hill set back from the road about twenty feet in. Across the street was a public park and diagonally across the park was the summer home of my father's oldest brother, my Uncle Jerome Alper.

Many summer days and fall weekends were spent in the pursuit of cleaning up and modernizing our summer home. In addition to modernizing the kitchen (which was in a state of 1920 historical insignificance), my dad and my mom had a special room built on the rear of the house.

The first few summers at 506 Third Avenue were typical for the time. My mom and I would get down toward the end of June, of course, after I was finished with school and was officially on summer vacation. My grandparents would join us there, and dad would make it down weekends

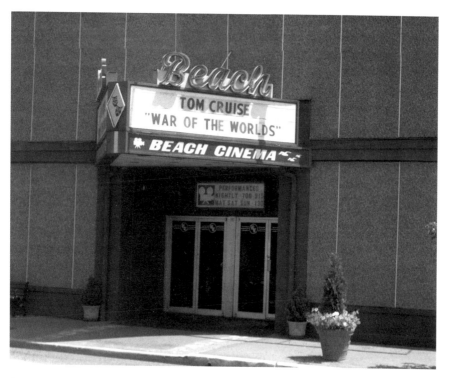

Beach Cinema. *Photo by Sam Ballen.*

and holidays. My grandmother would walk down and sit on the boardwalk with a friend and then my grandfather would come and join her.

The most fun was getting to know my cousins better and making new friends. We kids would spend hours and hours in the water, swimming, hanging onto the ropes or just sitting at the water's edge. At nighttime we would either have dinner at home or at one of the local restaurants (Fourth Avenue deli—great pastrami and corned beef—Vic's for "tomato" pie (pizza)) and then call it a night, watch TV or go to a movie at Bradley's Beach Cinema. Sometimes my mom would take me to the Bradley Beach library and very subtly suggest I get a good book to read. One summer I read lots, including the most recent Philip Roth bestseller *Portnoy's Complaint*. Once a month the town would sponsor a concert for the parents at a bandstand that they had built along the beach between Fifth and Brinley Avenues. Across Ocean Avenue was the town's newest house of worship, the Syrian Jew–built synagogue, out of which they would tumble on any given Saturday afternoon as soon as the morning prayers were over.

By the summer of 1965, Bradley had begun to hit its zenith. During the winters of 1964 and 1965, a great number of what we called the "Syrian"

Jews had begun to leave the confines of Brooklyn and their New York beaches and descend onto Bradley Beach, buying up everything in their paths, including some of the biggest and finest homes in Bradley. Those that had not been modernized were now modernized, those that were small were made bigger and those that were nice were made grand. Not many of them socialized with us, calling us the "J dubs." On some Saturday nights the town, under I believe the leadership of Mayor Lowenstein, began to sponsor single dances for the kids. It was then and there that I began to make new friends. It was there at the Fourth Avenue pavilion that I first fell in love with a girl named Jodi. It was there that I started to experience the excitement of the Motown sound. It was there that I started to become a preteen. It was there that I befriended Joel Nasser.

Joel Nasser was a kid about my age who decided to buck the trend and became very friendly with us, including our families, despite his being a Syrian Jew. It was with Joel Nasser that I discovered the two lakes at each end of Bradley—Fletcher Lake at the north end and Sylvan Lake at the southern end. Both freshwater lakes were used to separate Bradley from Ocean Grove at the north end and Avon-by-the-Sea at the south end. I remember rowboating in both.

In the end of December 1963, just one month after John Kennedy was assassinated by Lee Harvey Oswald, my mother's brother died of liver cancer. It was a particularly hard blow to my grandparents, who would later that year relocate from Newark to Stuyvesant Village in Union and finally, by 1965, to 200 Ocean Park Avenue, Bradley Beach. This brand new apartment building owned by Marcus Wiener, a local developer and Holocaust survivor, had been recently finished and was loved immediately by my grandparents because it had a window in the kitchen and outside balconies from which you could see the beach and the ocean. It was situated right next to the Janet House, which had become a popular destination for families with kids. It was also around then that I became familiar with Newark Avenue—the stores and the rooming houses where lots of kids would stay. The 1960s were in full swing.

Let's see...the Righteous Brothers' "You've Lost that Lovin' Feelin,'" the Beach Boys' "I Get Around," Tommy James and the Shondells' "I Think We're Alone Now"; nights at the Brinley Avenue Arcade; playing pinball all night long; meeting Paul Pomerantz (the Beaver) on Newark Avenue; Fred Prisbell on the beach; singing "Like a Rolling Stone"; free pinball in the cellar of the LaReine-Bradley Hotel with Robert Karlsberg; hanging out with Ricky Friedman and Jack Sobel at Mike & Lou's (great hot dogs, phenomenal French fries); the Brinley Avenue Pavilion where I first met Matthew (Bradley's own "Bob Dylan"); forays into Asbury Park

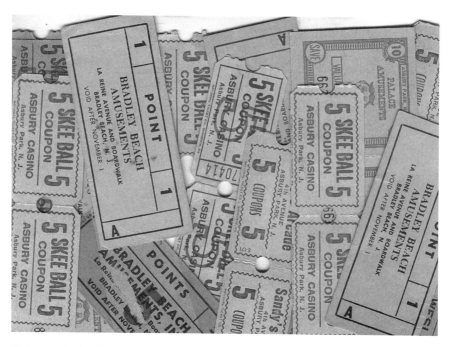

Tickets and points from various shore arcades. *Author's collection.*

for shopping and at night Boardwalk fun; Kohr's custard; the Paramount Movie Theatre for first run movies; late night at Upstage with the likes of Southside Johnny Lyon and Bruce and other Jersey Shore rockers; still later night, the Windmill for hot dogs and burgers.

The year 1968 was to be the culmination of all that was going on in our surroundings: the Tet Offensive going on in Vietnam and being broadcast into our living rooms; the assassination of Martin Luther King; the presidential primaries; LBJ drops out after New Hampshire; Gene McCarthy versus Bobby Kennedy; Nixon's the One; assassination of Bobby Kennedy; the DNC in Chicago; riots in Los Angeles and Newark.

Hair-in in Bradley? That's right, there was a hair-in the Fourth of July weekend. It all began when some of the local Bradley cops started a rumor that all persons with long hair would be banned from the Brinley Arcade and surrounding boardwalk and pavilion. Someone with connections had telephoned a local radio station and on the air encouraged anyone with long hair to come down to Bradley Beach for the Fourth of July weekend and participate in the First Annual Hair-in. This was quickly picked up by other local media, including the *Asbury Park Press*, which began immediate coverage. Well, suffice it to say that a major protest demonstration was being planned.

It didn't really come off—before a major conflagration cooler heads prevailed and so we had our hair-in, although most of us participating were not of long hair. But what had begun as a matter of challenging authority turned into the beginning of a change for Bradley Beach. First the Syrian Jews discovered Deal and began to sell out en masse. Then those who couldn't dump the big houses began to take in group rentals and the like. Then a different class (or element) of people began coming down. All of this began slowly at first; those of us who populated the Brinley Avenue beach began to see it when the beach didn't seem so crowded anymore on weekends and holidays. First the card games began to end. Next came the discovery by the older group of the sins to be had in Belmar. By the end of the summer of 1969 we all held our collective breaths because we knew something was about to give.

And it gave. The summer of 1970 began innocuously enough. But then it happened: the riots of summer 1970 in Asbury Park—less than two miles from our little enclave at the Jersey Shore. Nothing was ever the same after the Asbury riots of that summer. In fact, my parents and I skipped the 1971 and 1972 summers down the shore altogether. My parents opted to rent out the house both summers to one of the last Syrian Jew families to come down to Bradley.

In 1973, to try to get the summer off to a great start, I decided to have a Memorial Day weekend party at the house. I invited three of my friends to act along with me as "hosts." And then we invited anyone and everyone, and believe it or not anyone and everyone came. They say that we cleared out the Janet House and brought 'em to the Alper house. To this day every once in a while I run into someone who was there and they comment, "Good party," thirty-plus years after.

We all continued to spend our days at Brinley Avenue beach, which was dubbed the "teenage" beach even though by then most of us had come into our twenties. But by the end of summer 1973, most of us had graduated to Belmar, where our college friends were hanging out and the nightlife had shifted to after the riots in Asbury. The most celebrated of the bars across from the boardwalk was D'Jais, where they sold six-ounce beer, five for a dollar. Then there was the Royal Manor South (in Wall Township), where I remember seeing Bruce and the E Streeters for a five-dollar cover fee.

The next few summers really began to illustrate what was happening. First the group rentals were in full swing, but by then the local politicos had had it and so had begun to try and appeal to the young marrieds with kids. They started a "family fun in the sun" initiative and down came the pavilions and the schlock boardwalk amenities, beginning with the Fourth Avenue shops and lockers, followed by demolition of the LaReine-Bradley

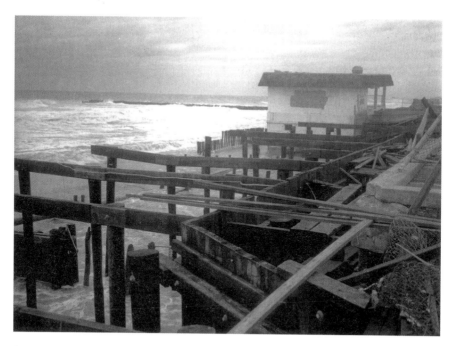

Destruction on boardwalk from winter storms. *Courtesy of Janet Ballen.*

Hotel (a virtual icon of the Bradley Beach of yore). Condos were built in its place. Next came down the arcade and surrounding pool of all our younger days.

To be sure, this took place over a few years and not right away, and we did steal a few more good times during those summers. In fact, the summer of 1978 my parents allowed a group of my friends and me to spend the summer at the house and although we did spend that summer at the house, things were much different. We spent our times either at Second Avenue beach (by then the storms of the 1970s had caused a great deal of beach erosion at Bradley and the Brinley Avenue beach, once so wide and spread out, was now a thin strip of meager sand) or with our other friends at Belmar.

Nights were either spent at the bars in Belmar and Wall Township or at home in front of the TV set (cable was then all the rage). Every once in a while we would catch a concert being staged by one of those great Jersey Shore bands (Southside Johnny Lyon and the Asbury Jukes, Cats on a Smooth Surface, Edgar and Johnny Winter, Meat Loaf), and most of these were put on at the Stone Pony in Asbury Park or some place I can barely remember in Long Branch.

The early 1980s were cruel to the Bradley Beach we all knew. By then, virtually all of the Syrians had sold out and gone on to Deal. The state

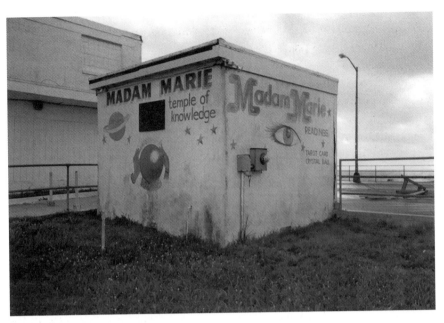

Madam Marie's Fortune Telling "Temple of Knowledge," Asbury Park. *Author's collection.*

had begun dumping inmates from the big mental institutions into smaller group homes in places like Asbury and they began to trickle into Bradley, as did some of the lower element of society. Gone were the urban/suburban Jewish families. Nationally there was a recession going on and real estate sales were stagnating. My (our) generation had come of age and Bradley Beach was no longer a destination on the horizon. Yet I was to have one more run at Bradley Beach. On May 17, 1986, I was married to my now ex-wife Meredith. Having been born and raised in basically landlocked states, Meredith, on visiting me, had come to love the Jersey Shore. And so we moved into my parents' Jersey Shore home and began to try and renovate it, since the last construction and repair had been done way back in the 1960s.

I was to spend four more years at the house in Bradley (but this time year round). I was to get active in local affairs, including politics, both local and countywide. Eventually I became the local "boss" of Bradley Beach after building a political party from the ground up and igniting the match that led to the end of the old form of government in Bradley. Our influence became so great that we were actually the deciding town in a special assembly election. By the time I left Bradley for good (1990), the town had started to take on a much better element of people. Neighbors began taking pride in their homes again. Attitudes were on the upswing. People began returning

to the newly replenished beaches—even some of my generation, now with young families—to repeat the process.

Now what has become of Bradley Beach? If I had remained in my marriage and we had had children, I believe I would have either remained there or summered there. A few of the old crowd venture there with their children, if not for a weekend or a week then at least to visit and stop and check out the old places. They tell me you never know who you will find lurking on the boardwalk or the beach.

Moving Out

By Debby Greenstein

I moved to Bradley Beach in 1952, when I was six and my sister was two. I fell in love with it immediately, and love it still. My family had roots in town and my dad vacationed there as a child. In the 1930s, his aunt owned a house on Second Avenue. When we moved there, his uncle lived in the Mayfair Apartments and his cousin owned Jack's Hardware, located on the corner of Main Street and LaReine Avenue, where the Keith, Winters & Wenning law firm stands now.

To understand what made Bradley Beach work, you need to see it from the perspective of its year-round residents. The visitor's excitement of going to the beach for the summer was replaced by the glory of living there all year round. But it wasn't a vacation; it was home, and for some of us that home helped support our families.

For many years, Bradley Beach was the summer resort of choice for a group of Jews of Syrian ancestry who lived in Brooklyn. Every summer they would come to Bradley Beach and rent a house for the season. The men would commute to New York on the train while the women and kids spent the summer down the shore. Over time, those families became homeowners as well, first in Bradley Beach and later in Deal.

What this migration meant to my family was the ability to buy a house by renting it to a Syrian family in the summer. What that meant to my sister and me was a summer of relative freedom. What it meant to my mother and father was a lot of hard work.

The season began in the spring, with the arrival of what my father referred to as "rental cars." These weren't cars from Hertz or Avis. They were the cars the families drove to Bradley Beach to look for a summer rental. Instead of the new Cadillacs or Lincolns they drove all summer, the house seekers arrived in old Chevys and Fords. We thought it was meant to prove that it had been a bad year and they couldn't afford an increase in

rent. Did it work? I suppose the answer would have varied by whether you asked a Syrian family seeking to rent a house or a Bradley Beach family offering one for rent.

Once the deal was struck, the work began. The house had to be readied for renting, which meant lots of cleaning in the days when spring cleaning still existed. Curtains were taken down and washed. Slipcovers were put on the furniture. Family treasures were packed and hauled to the attic for safekeeping. The winter clothes were cleaned and stored. Almost everything else needed to be packed as well, because it had to be moved to wherever you would be spending the summer. Come fall, this all had to be done in reverse.

Probably the most complex move for our family was in the summer of 1967. I graduated from college, headed to a summer job in Washington and had to be in Ann Arbor for graduate school before Labor Day. That meant a major exercise in triage as we packed things for Washington, stored possessions in the attic and took to the summer bungalow anything that would be taken to Ann Arbor.

This all sounds like a lot of work, and it was, but it was also a wonderful break for our family. There was a major reduction in housekeeping and yard work. My mother's tight standards really did get relaxed. That meant more time for the beach and boardwalk for the whole family and for the golf course for my father. As young teenagers, my friends and I hung out on the beach with the Syrian kids. To this day, I can insult you with the little bit of Arabic I learned from them.

For many years, we rented a bungalow on Fifth Avenue that was right next door to the one occupied by close family friends. My sister and I loved having our friends so close and much time was spent running around the fence to visit.

It was a wonderful time and our Bradley Beach connections make it such a small world.

Bradley Since 1917

By Carole Levine Rothman

Our family has many ties to Bradley Beach in different ways. We were three girls, my sisters Marjorie Levine Bobker, Rita Levine Gaber and I, spending years at the Jersey Shore. Our parents, Frances and Abe Levine, even spent their honeymoon in August of 1917 at the Sea Cliff Hotel in Bradley Beach.

Carole Levine
Rothman, *left*, and
Gladys Gordon
Blum, August 1942.
Author's collection.

We stayed in bungalows for many years. In about 1937 things changed and we began spending summers in a very small rooming house at 212 Ocean Park Avenue. It was a family home. They rented rooms to friends and families they knew. Members of their family even slept in the attic. Mr. Kafinsky, the owner, was a cop who checked badges. One of the girls, Mae Schaeffer, and her husband owned the concession, a candy store, right on the boardwalk. Mae and her sister Sara Schaeffer were good friends of our family.

We went away all day and our mother took the double-decker bus to Asbury for hot baths, always bringing us back goodies from the Berkeley Hotel. Our dad would drive down Wednesday overnight and come again on Friday for the weekend. There wasn't any parkway or turnpike at that time.

We all had fun times together in Bradley. We went to Mike & Lou's for hot dogs under the LaReine Hotel. Our mother played bingo every night and we always found fun things to do on the boardwalk.

Before we returned to the city my mother would take my sisters and me to Asbury to buy school supplies and clothes. I think the department store was Levinson's. We also had fun going to Asbury and the movies on rainy days. We loved the double-decker buses. Lots of time we just walked on the boards from Bradley, past Ocean Grove and on to Asbury. We even saw concerts in Ocean Grove.

In 1945 we rented a house in Belmar as our family grew. I was married on February 22, 1948, and our family began renting houses in Allenhurst, Loch Arbor, Deal, Elberon and West End.

Things changed again after my daughter was born over fifty years ago. My sisters and I would take day trips to Phillips Beach with our children. Marjorie joined the Crestmont Country Club in 1950 and Rita and I joined swim clubs as my daughter's friends did the same. But for so many years we would still come down to the Jersey Shore for one day.

I will never forget all the wonderful years we spent in Bradley and other parts of the Jersey Shore.

Summers at the Shore

By Nathan Jacobson

Are you aware that it is only people from New Jersey who call the seashore the "shore?" Others have other names for it, but I am told that if you meet a person who refers to it as such, you will be listening to a New Jersey person.

My first eight summers were spent in Belmar, New Jersey. There, the family took one house and all stayed in it from the day after public school ended in June to the day before it began again in September. The family was the Tarrs. My grandmother and grandfather, Ida and Joseph; my Aunt Rhea with Carol and Dicky; my Aunt Fan with Gladys and Billy; my Aunt Thelma, who was unmarried for the first few summers; my parents and me and later along came my sister, Joan.

For the first few years Rhea was married to Martin Korngut. Martin and my father commuted from Elizabeth and Newark, respectively, each day. So each evening there were fourteen of us for dinner. My Uncle Marty, my mother's brother, a lawyer in New York City, came occasionally for a weekend, also by train.

My grandfather did the food shopping at a market where he could buy in bulk. As I remember, he would buy a bushel of vegetables and we ate

that each day until it was almost gone. My grandmother spent time in the kitchen. We children spent our days on the beach from early in the morning until lunchtime and then returned to the beach until dinnertime. We camped out near the lifeguards' stand and they were asked to keep an eye on us, a task for which they were rewarded at the end of the season.

The house was a big old thing on Tenth Street between Avenues A and B in Belmar. Each family unit got a bedroom. We shared our meals in a large dining room with a table large enough for all to eat at the same time. It was also a place to play a game of Michigan rummy for pennies, which we were not allowed to keep. There was a big pot of pennies. The house had a large garage in the back with living quarters above. Most years Mort and Edna Green and their sons, Bobby and Donald, occupied it. Edna was a longtime friend of the family.

These summers were during the Great Depression and money was scarce. I remember hearing my father once say that the rent was just enough to let the owners pay their real estate taxes. I was also told that those in this family who could pay contributed what they could, and that is how the rent was gathered. It was a big house that had a large porch on the front and one side, where we could play when the weather was rainy. Across the street was a lot where we could play baseball and other games, and there were wild onions or scallions growing in the sandy soil. These we learned to pull out and eat. Next to the lot was another large house owned by a man who was always referred to as Judge Quigley.

Having been born on July 2, and because baby boys and their mothers stayed in the hospital until the baby's brit milah, my first night outside of Beth Israel Hospital in Newark, New Jersey, was spent in the front bedroom of the house in Belmar. The room was on the second floor and had a little porch off of it. I am told that I cried so much that first night that my mother was ready to throw me off the balcony, but was dissuaded by her pure love for her firstborn.

My memories of those summers obviously begin a few years later. They were good summers. The atmosphere was warm and inviting—that is all but my cousins Billy and Dicky. They were two and one and a half years older than me. Most times they accepted me, but when they wanted to get rid of me or just to be mean to another human being they would call out that the fire engines were coming and I would run to my parents crying. I am told that I was afraid of fire engines, but I don't remember having such an affliction. In fact, by the age of four my favorite toy was a fire engine in which I could sit and pedal around.

Aunt Thelma would, on occasion, have a weekend guest, a suitor (the term used in those olden days). My grandmother wanted to be sure that

he had a good time and so would be sure that the suitor (sounds like a cast listing in a Neil Simon play) was taken fishing by the men. That really wasn't a good idea. They were practical jokers. It was a time when men wore white shirts, plus-fours and black bow ties for an occasion like fishing. The effects from grape soda in a dribble glass and mustard on the benches of the fishing boat were soon obvious, to everyone's delight but the visitor's.

The regulars were not immune to being the butt of jokes. My father related that the first time he went fishing no one was having any luck. The captain suggested to my father that his bad luck was the result of having failed to rub "belchin" oil on the hook and sinker. This he did while everyone was laughing at my father's expense. He was a lucky guy and he was the next person to catch a fish. It wasn't until that evening at dinner when he was regaling us all with his prowess as a fisherman that he suddenly caught onto the joke.

Dinner was always a tumult. There were so many of us and we all ate together after a day on the beach and a shower (outside) and clean, white shorts and shirts. Sometimes after dinner we had a treat. We walked the block or two to the store on the side of the Hollywood Hotel, which was at Ocean Avenue and Tenth Street, and there we could purchase a Fudgesicle for three cents. That was heaven.

I remember having to wear a metal beach tag pinned to my bathing suit. This told the world that I had the right to be on the beach. Dress codes were different then and they were enforced. People were not permitted to walk on the streets clothed only in a bathing suit. As a result, all had light cotton summer robes to wear from the house to the beach.

The distance from the boardwalk to the water seemed quite a hike to a little one. A large area of the water in front of the lifeguards' stand was roped off. The ropes were attached to piles driven into the ocean floor. As time went on they became covered with a slimy green plant, as did the ropes. It took great strength to hold onto the ropes when the weather and surf were rougher than usual. There were times when a wave would come and detach me from the ropes and tumble me upside down. I would gulp down great amounts of salt water and wonder if I was ever going to come to the top again. The peculiar thing about this was that as frightening as the experience was I enjoyed it and went back for more and more.

As you approached the water, at the edge, the sand gave way to pebbles, which to young tender feet were uncomfortable. As a consequence, we wore small rubber slip-ons on our feet. Remember them? They were most uncomfortable when sand got into them. Sand made us more uncomfortable in other areas of our bodies. Do you remember the woolen bathing trunks that never seemed to get dry? Do you remember the way the sand collected

"Dressed to fish," David Gordon. *Author's collection.*

in the most uncomfortable place in the suits? Do you remember the sand in the peanut butter and jelly sandwiches?

Do you remember how hot it got on the beach on those especially sunny days when there wasn't a cloud in the sky? I do. I also remember that the most comfortable place then was under the boardwalk. There it was always cool and damp. There also we spent time looking for soda bottle caps and Dixie Cup lids with pictures of movie stars on the underside. Most of all we searched for the Popsicle sticks with the words "lucky stick" imprinted, which entitled the finder to a free Popsicle. We later learned that there was no such thing.

View of Asbury Park. *Courtesy of Shirley Ayres.*

On Saturdays we had a treat—sometimes. We each were given ten cents and permitted either to go to the movies or take an excursion to Asbury Park. To do so we had to walk through Bradley Beach, Avon-by-the-Sea and Ocean Grove. The last was a Methodist camp meeting and very, very quiet, especially on Sunday. There was a kiosk in the middle with a model of Jerusalem or Bethlehem.

At the dividing line between Bradley and Avon, on the boardwalk, was a skeet-shooting club. One summer, much later on, my Aunt Rhea was running a boardinghouse on Evergreen Avenue in Bradley across from the lake. It was right there that the shooting club was located. We were a little older and still a little dumber and we collected the spent buckshot shells. They had brass ends and we decided to salvage the brass for sale.

By the time we reached Asbury Park we were tired and thirsty. We always got hung up and spent a few of our pennies at the kiosk of "all the soda we could drink for a small fixed number of pennies." There were all flavors available. However, they all tasted the same, but just didn't have the same color. The rest of the money was spent at various pinball machine parlors. We could only play the simple ones; the electrified ones with lights and bumpers were a nickel a play and that was beyond our resources—especially after soda and ice cream.

I don't remember the rainy days but there must have been some. I am sure that we were no different from other children and that rainy days were not a delight for our parents. There was the porch around the house and of course playing in the rain of a warm summer day. But best of all were the two movie houses. One was the Rivoli and the other was the Rialto. One was in an old building somewhere on Ocean Avenue, I believe, and the other was on Avenue F. I think that the roof leaked on Ocean Avenue. It was there that I saw for the first time Paul Muni and Louise Rainer in *The Good Earth*. On one of the days when the family was packing to return to the city we were sent to the other theater and told to wait until someone came for us. We did—and we stayed and saw the pictures two or three times—and the serial and the cartoons and news.

Life was good.

The Sea Cliff Hotel (1920–1932)

By Elenore G. Peckerman

The Sea Cliff Hotel, owned by Hyman Sirota, was on McCabe Avenue. Our bathhouses were back to back with the LaReine Hotel. We went to the shore every summer for eight weeks, from school closing until after Labor Day.

We had a special routine at the hotel. To announce meals, a bell was rung in all the hallways when it was time for breakfast, lunch and dinner. No bathing suits were allowed in the dining room. Our house band played during every lunch and dinner. All of the guests were seated, and then my grandmother and grandfather entered the dining room while the band played. The meal was then served family style.

My grandfather's chauffeur picked up the guests upon arrival by train. The hotel had a ballroom where masquerade parties, mock weddings (and sometimes real weddings) and shows by the staff were held. The band played all evening so that guests could dance to their hearts' desire. There were also card rooms where both men and women could play the game of their choice.

Even though we were in a hotel, the youths were basically unsupervised. We were free to go to the beach, to the saltwater swimming pool, to the pavilion…even to walk to Asbury Park. Once in a while the kids would let the adults tag along.

My time at the beach has given me a lifelong love of the ocean and memories I have cherished all my life.

BRADLEY BEACH ROOTS

By Phyllis Reich

As I write this, it is April and I'm psyched because this very day the plumber is restoring the water system in Bradley Beach…getting ready for another season. I'm still ecstatic over the prospect of spending another summer at my favorite place after all these years, and I stress "all."

My parents bought our house in 1945 for $4,500, a staggering amount at the time. I spent every summer there, even through college. During the early years of marriage and having babies, I visited my parents but didn't stay the entire summer. When my mom died, my dad had no interest in continuing there and offered it to us, which we accepted. So our kids then had the joy of summers at the beach, interspersing with camp, travel and education, but always happy to return to Bradley.

My list of memories is long. One probably only applicable to my generation was collecting empty soda bottles to return for a refund of one or two cents. What an accomplishment to have a fistful of pennies and be able to spend them on the games we invented and made out of sand under the boardwalk! Those games occupied us all day long and were our "video games." We also used, as payment for the games, Popsicle sticks that people had discarded and left in the sand. We didn't know about being germphobic!

Dedication on boardwalk bench for Phyllis and Jerry Reich. *Courtesy of Phyllis Reich.*

Dedication on boardwalk bench for Sherman family. *Courtesy of Phyllis Reich.*

About nine years ago, when my grandson was eight, we were driving through abandoned, forlorn Asbury Park. I was trying to describe the glory days before the race riots of the '60s: the rides, fun houses, golf, Kohr's, Mrs. Jay's. He listened, rapt, and then said, "I hope when I have grandchildren, I'll have such interesting stories for them." He then said, "This must have been a beautiful place to grow up in." How right he was.

BRADLEY IN THE 1950s

By Elaine Yelner

I spent the summers in the 1950s in Bradley Beach. My family stayed in a different place every summer. My first memories of Bradley were of a bungalow off Newark Avenue, which we shared with two other families. The following two years we stayed on Ocean Park at a place owned by the Kaiser family. I think they had a daughter who lived in Springfield with the last name of Kaston.

At the Kaiser House, we rented the top floor with two other families and shared three bedrooms and one bathroom. Other summers we spent at a bungalow on Brinley Avenue or in a rooming house next door to the bungalow. Later years we spent at Frank's Place. I think it was the second or third block of Brinley.

My memories of these types of places are of the kitchens, where you had to share a refrigerator and a sink with another family. You also had to share bathrooms with other people who you did not even know before you checked in for the summer. There were always good smells from the big kitchens. All the women would cook and share recipes. There was also lots of gossip. All the places always had big porches where everyone gathered and chatted late into the night.

I remember pretty well that on the weekends, if the rooming houses had any vacancies, they would rent to the teenagers who would come down. Usually they were guys and gals who probably told their parents that they were staying with friends, but we all knew what was going on there.

I also remember walking to Newark Avenue to food shop for my mother. When it rained and we could not hang out at the beach and the mothers wanted to play cards or mah-jongg, they sent the kids to the movies on Main Street near Vic's. In those days you could go to the movies for nine cents; the refreshments they sold cost more than the movie.

Everyone talks about Vic's, but we also loved to go to Mom's Kitchen in Neptune. I still visit Mom's Kitchen. Of course when it came to eating, the hot dogs and especially the French fries in the brown paper bag were the best at Syd's. On the note of food, I remember the vendors' trucks that rode around. The mothers shopped off the fruit truck and, of course, the Freedman's Bakery truck with the fresh seeded rolls and doughnuts.

I walked the boards to Asbury Park with my friends a few times a week. We always giggled walking through Ocean Grove. We never seemed to walk off the boards there, but now we do go to the theater in town. I even remember the chains they had up from Saturday night to Sunday to block cars from driving in this town with strict blue laws on Sundays.

I thought that anyone who stayed at the LaReine Hotel or the Bradley Hotel was very rich. In fact, I was friendly with children whose parents or grandparents owned the LaReine and was always in awe of them. Some friends of my parents stayed at a rooming house on Park Place, and they had a pool there. We were so jealous!

I also remember fun at Fletcher Lake. And was there a grocery store in a big rooming house called Ruskin's? The arcade on the boardwalk was fun and the machines were broken so often that we got free games.

In the mid-'60s I rented a place for two weeks and took my children, but it was not the same as when I was a child. Sometimes you cannot go back. But we do go back there now to walk the boards for exercise and to get fresh air in the fall and the spring. And the memories never leave us.

Vic's Restaurant
anniversary t-shirt.
Photo by Matt Johnson.

My Wonderful Memories of Bradley Beach

By Sandy Kaston

My grandfather owned a rooming house at 111 Ocean Park Avenue. During the summers, it was mostly filled with little old Jewish ladies who were widowed. My family got to stay in the refurbished garage (bungalow) in the backyard. From the year of my birth in 1957 until around 1972, I spent all of my summers there. It was quite something, as every time I would enter into the main house I would be greeted by at least ten different women who acted like my surrogate grandmother. There were always delicious smells emanating from the kitchen area.

Unfortunately, after my grandfather passed, my mother and uncles decided to sell the place, as they didn't want to run the rooming house business. The sad part is that back then it was sold for around $42,000. Today it is worth many hundreds of thousands of dollars more. Oh well…

Anyway, I recall that as soon as school got out, my parents would pack up both cars, the three kids and the dog and make the "long trek" from Springfield. Although it was only fifty miles away, once we crossed the railroad tracks into Bradley Beach, it seemed like we were worlds away. My dad would join us on Wednesday nights and then on the weekends. The family didn't go back north until Labor Day. So from the end of June until Labor Day, I had Bradley and the other local towns as my playground.

I had my "summer friends" to keep me company. I recall the summer before entering kindergarten, my brother Arnold and I were on the side of the house tossing one of those inflatable life rings back and forth. A gust of wind came and took it over the bushes into the next yard, right to Mrs. Gallon's house. As my brother went to fetch it back, a young girl and her brother brought the life ring over to us. Turns out that the young girl was my older brother's age and the boy, Mark, was just a year older than me. Ah, new friends.

I'm delighted to say that Mark is still a very close friend. There were others also. I remember my mom calling me into the front house to meet some woman. Turns out that the woman was the mother of a young boy, Skippy, who was close in age to me. Skippy and I met and instantly hit it off. He was a Bradley Beach local who lived in town all year round. His parents rented out their large home on Fifth Avenue and then rented a smaller summer bungalow to supplement their income. His dad ran David's Beauty Shop in town. Sometimes Skippy helped out by washing women's hair. There were so many kids around during those times (early 1960s) that making new friends was easy.

Mark's family rented from a different landlord each year, which worked out great for me. Both Mark and I made new friends, most of whom were neighbors at Mark's new summer place. How convenient it all was. One of those kids was Bruce. I'll never forget one time, Bruce came to me and said he had just bought a boat. He mentioned that he'd like to bring the boat to his yard so he could fix it up before launching it into Fletcher Lake. Bruce and I got his sister's baby carriage, the kind with the big wheels on it. We went over near Fletcher Lake, got the boat up on the carriage and began to transport it back to Bruce's house on Ocean Park Avenue. Just then a police car arrived, with an adult not far behind. He was screaming something at us. The policeman asked Bruce where he was going with the boat. Bruce told him. When the policeman asked why, Bruce told the officer that he had just bought it from some kid for five dollars. Turns out that the kid who Bruce bought the boat from didn't own it. Oh well, live and learn...

As we got older, my group of friends and I would walk by ourselves into Asbury Park to play the games of chance, ride the rides and, eventually, attend some great concerts in Convention Hall. Those were carefree days. I recall seeing movies at the Strand in Ocean Grove, grabbing a Kohr's frozen custard on the walk home or making the trek into Asbury, just to get a bag of hot nuts from the Planter's Peanut store.

When we weren't walking into Asbury, we were hanging out at the Penny Arcade on the corner of LaReine Avenue. To this day, I still remember spending hours and hours trying to beat the King of Diamonds pinball

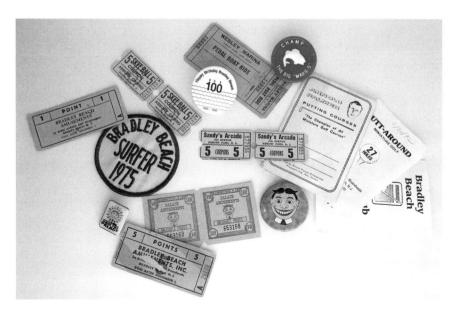

Bradley Beach, Asbury Park and Belmar memorabilia. *Author's collection, photo by Matt Johnson.*

machine. Hanging out in front of the arcade or on the beach out front with a group of ten to twenty kids at any one time was the norm.

We also went fishing in Fletcher Lake. I had a crummy little fishing pole that wouldn't cast. I remember the Chinese kids who had good casting poles. They caught big carp. All I ever caught were little sunfish. We used to buy our fishhooks and penny candy at Virgil's. Then we would buy pizza at Joe's on Newark Avenue. We were carefree and footloose—just joking around and hanging out.

When I was very young I remember laying in my hot bed at night. We didn't use a fan, let alone an air conditioner, and due to the excitement of the day, it would be difficult to fall asleep at night. Then the races would start. I guess, since the bungalow was built on a slab, I felt the vibrations of the cars racing up and down Ocean Park Avenue in the middle of the night—yup, they really did go racing in the streets!

I also recall that when Bruce turned fifteen, his dad bought him a real boat. Bruce attended the Naval Academy, so he seemed to know what he was doing. The boat was docked at Belmar Marina. The boat opened up a new world for us. Although I rarely went fishing with Bruce, as I used to be a late sleeper, we got out on it quite a bit. I do recall a Memorial Day weekend when Bruce and I took the boat out into the ocean. Memories of being towed back in are still bright as day. I guess Bruce needed to learn more at the Naval Academy!

Fletcher Lake Bridge. *Photo by Sam Ballen.*

I remember one particular day when Mark and I were hanging out on the swings on the boardwalk near Park Place Avenue. It was a raw kind of an evening. I remember two girls walking up on the boardwalk. Mark's older sister was friendly with one of the girls' older sister. The girl Mark knew was Bette, the one and only. Bette's friend was giggling and just acting silly. I didn't think much of it…until the following summer. I remember moving to the shore after school got out in 1972. A friend from "up north" who also spent summers in Bradley had stopped by to see if I wanted to go to the beach with him. I think this was the year that I finally moved up to the "teenage beach" on Brinley Avenue. I cut my pants legs off to make a bathing suit. We got to the beach and I tossed my towel down. Then I noticed her. It was that silly girl who had been with Bette the night we met on Park Place Avenue. Without going into all the details, I ended up marrying her—Leslie. Yes, like so many others, I met my wife in Bradley Beach.

Years later, I proposed to Leslie, near the same spot we had met on Brinley Avenue beach. A few more years later we married, settled down and had three children. Two of them are named for Bradley Beach. Our

oldest son is Bradley and our daughter is named Brinley. At a reunion party that Bette organized during the summer of 2004, Leslie and I were given an award, along with two other couples, for meeting and subsequently marrying someone we met in Bradley Beach. We even received a special mention for actually naming our daughter Brinley!

Leslie and I still hold Bradley Beach very dear to our hearts. Although my family had given up on Bradley when my grandfather's rooming house was sold, Leslie's family did not. Even before we were married, Leslie's folks always made room for me to have a place to stay. Later on, we brought our children to Bradley Beach to spend summers.

However, things have changed. No more Penny Arcade. Asbury Park went downhill. A hurricane took away the boardwalk, to be replaced by the brick walk. Kids go away to summer camp now. Bradley Beach today is different than it was back in the 1960s and 1970s. Call it progress. My kids still feel Bradley is a special place, but as they've gotten older, they prefer to go places where their friends are.

My parents were first-generation Americans Jews who came to Bradley to escape the heat of the "city" during the summertime. Today, Bradley has new immigrants and their children. It's no longer referred to as "Bagel Beach," which is really okay, as the next generation makes its own memories.

But I still remember the sand in my toes, hopping down the beach so I didn't burn the bottoms of my feet, the first feel of the icy water, the feelings of the beach, surf and of all those friends I made in my youth. They say you can't go back. Maybe you can't. But as an aspiring young songwriter from Freehold once wrote, "Tonight tonight the highway's bright. Out of our way mister you best keep, 'Cause summer's here and the time is right, for goin' racin' in the street…"

Ah, memories of summers in Bradley Beach. Just the thought of it brings a smile to my face.

MY MOTHER RITA

By Rich Weissman

My mother Rita loved the beach, Bradley Beach specifically. In Elizabeth, the last day of elementary school was only an hour long, and I would be home by 10:00 a.m. The car would be loaded and we would set off down the shore for the summer. While we had been staying in Bradley on weekends since Memorial Day, the start of full-time summer was always a cherished time.

The end of June was always the best, as it was the head start of summer. Come July Fourth, the summer took on a familiar pattern, but during the

Having Fun. Postcard with beach scene near lifeguard boat. *Author's collection.*

couple of weeks leading up to that, it was always interesting to see which friends were coming back and what the summer was going to be like. You always knew that the friends you saw moving back in June were from serious beach families like us.

My mother always had a deep tan, a ready laugh, beach snacks and a quarter for the arcade. She often held court on the beach with a large group of friends and family. She was a fixture through the '50s, '60s and early '70s on the Fifth Avenue beach, sitting to the left of the stairs toward Brinley Avenue.

She passed on more than thirty years ago, but my memories of her in Bradley Beach are the strongest. If there is a beach in heaven, she is on it. By now, she is also with most of the friends and family she sat with. It is both sad and comforting at the same time.

Every day is a beach day, Mom.

CLIFF VILLA

By Tim Tsang

"Bradley Beach; where is that?" my mother said. My uncle told her, "It's at the Jersey Shore!" That was 1939. He would look after me for two weeks at Cliff Villa on Cliff Avenue in Bradley Beach.

The Villa was run by the Church of All Nations of Houston Street and Second Avenue in New York City. They owned the facility in Bradley and

arranged time slots for various ethnic nationalities including Italian, Slovak, Japanese and Chinese. This was back when the property area was large and extended all the way down to the edge of Fletcher Lake. Now the Lake Terrace roadway occupies space between the lake and Cliff Avenue.

In those days, the Cliff Villa complex consisted of a large main house that provided a kitchen, large dining room, restrooms and sleeping quarters for married couples and single females. The single men and young boys were quartered in a separate small house apart from the main house.

It was a time for beach, games, outdoor showers, nights at Asbury Park, Sundays at the Ocean Grove Auditorium and happy memories of new and now old friends. I even first met a certain girl at Bradley some years later. A few years after that first time many of my uncles' friends and some of my uncles went into the service for World War II. Over the years, the property and the houses were sold by the Church of All Nations.

Eventually, the Chinese families purchased houses on Newark Avenue so they could enjoy the entire summer at Bradley. My grandmother followed some years later and purchased on Newark Avenue as well. That meant that my cousins and I could spend about six weeks down at the shore each summer. Around 1950 my grandmother moved to a larger house on McCabe Avenue. Bradley Beach was always a place to escape to from the city.

Later on, marriage and a family resulted in just a few visits to the shore until my mother purchased a place on Madison Avenue in 1962. Bradley was back as a place to go to in the summer. It was also a great time for my parents to take my children on the rides in Asbury Park.

Madison Avenue was a summer weekend trip through the years, while work and school kept us busy. It seems like, in a flash, all the children got through college, and all are married and have children of their own. Now we have nine grandchildren.

Nowadays, grandchildren are the reason for keeping our house in Bradley. Two families are in New Jersey, one in New York City and the other is in California.

Madison Avenue is still a weekend destination whenever other responsibilities or weather permit. Neighbors have remained fairly constant, which is great, and our street is pretty good concerning parking (especially after Ocean Grove dropped their blue law requirements some years ago). Bradley has also been rebuilding and refurbishing all over, which is nice.

Bradley remains a special place and experience. My grandchildren from California are coming soon, so their mother can let them enjoy some of the Bradley she knew.

So many of our friends of days gone by still ask, "How's Bradley?" It's a common link to happy days.

TEACH YOUR CHILDREN WELL

By Ronnie Bornstein-Walerzak

Although I travel to Bradley Beach every morning to my job at Bradley Beach Elementary School, formerly known as Bradley Beach Grammar School, the passing over the railroad tracks at Memorial Drive does not have the same thrill for me as it did back in the early 1960s. Back then, as a very young child, my family and I would make the trek down from our home in West Orange every summer.

What started as a two-week stay at a rooming house on Brinley Avenue progressed to a month's stay in a rear bungalow on Ocean Park Avenue. This was followed the next summer to a full season in one of the little bungalows on Brinley Avenue, connected to the "Eric House."

After several seasons of sleeping in other people's homes, my sister put her foot down and arranged a meeting, unbeknownst to my parents, with a realtor. Although I was young, I still remember how excited we all were when my parents bought a three-story house on Central Avenue between Third and Fourth Avenues.

This was a few blocks south from the bungalows and rooming houses where my friends stayed. I was now among the "locals," "townies" or all-year-round residents! It was a world away from the summer residents I had previously been comfortable hanging out with, but it was still Bradley Beach!

Bradley Beach—perching steadily on the boardwalk railing, playing games at the arcade, miniature golf, a saltwater pool, pavilion dances, Mike & Lou's, Syd's hot dogs and knishes, the Bunny Hop, beach badges, jetties, sand, narrow beaches, rolling waves—was a haven of pleasure for any impressionable adolescent. Impressionable especially if you were from "up there," north of the twin bridges, a summer resident, a BENNY!

Several times over the past thirty-plus years I have come face to face with past boardwalk and beach friends at my school during open house or curriculum nights. They were there as parents! I was going to be teaching the second generation of my summer youth! How bizarre, how unexpected! I can clearly remember one father continuously laughing as he stood in the back of my classroom with his confused wife, as they listened to me explain my art curriculum to a room full of other parents. He thought it was so funny that I had survived the '60s, '70s and now the '80s and that he would entrust me with educating his children. I guess the strangeness of

Bradley Beach Elementary School. *Photo by Sam Ballen.*

the situation affected both sides. His two children have since graduated and have become model citizens of the world, proving that he could produce wonderfully bright, normal children, and that I did not corrupt them with stories about their father!

I became a full-time resident of Bradley Beach in 1969. I had attended college in Michigan for two and a half years, living through the "Michigan Murders" and having my parents pull me out and transfer me to Monmouth College. I lived in Bradley Beach and commuted, becoming very acquainted with the local group of young people in town. They accepted me, even though they knew (unspoken as it was) that I was a "transplant," never a local, but one step up from a Benny!

Okay, time for an explanation:

B: Bayonne or Bergen County
E: Elizabeth, Edison or Essex County
N: Newark
NY: New York

There are other versions.

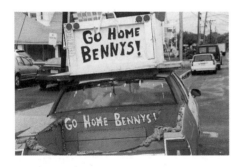

"Go Home BENNYs." *Courtesy of Steven Klappholz.*

Once I started teaching at BBGS it was difficult to live in a one-square-mile town and have a private life. So I migrated to other shore communities over the years—Belmar, Manasquan, Wall, Neptune City—and finally settled down in Ocean Township. I experienced many life changes over the years, as we all do, and continue to do so. I lost my dad, married, gave birth, got divorced, raised my child alone, laughed, loved, cried and tried to give my daughter the best life I am able to provide.

Standing on the boardwalk, facing north, you can see the construction of the multi-million-dollar high-rises in Asbury Park. Facing south, you can see the familiar Belmar fishing pier, many times renovated, but a welcome image from my past. I've never taken the time to think about this until now.

As I write these ideas down, a ladybug lands on my paper, reminding me of the days back when I was eight or nine years old and we used to chase ladybugs along the beach. We also collected many shells, sand crabs and sea glass. Now I am collecting my memories.

So every morning between September and June, I cross the railroad tracks into Bradley Beach, stopping at the 500 block of Brinley Avenue, and enter the large brick building that houses approximately four hundred eager students waiting to be educated.

I received a good part of my education in Bradley Beach; why shouldn't they?

JEFF, THE BRADLEY BEACH LIFEGUARD

By Jeff York

My family moved to Bradley Beach from White Plains, New York, in 1953, when I was three years old and my brother was four. We lived in various rental houses on Second Avenue, McCabe Avenue and Fletcher Lake Avenue. In 1962, my parents bought their first home at 106 Fletcher Lake Avenue, soon after the birth of my younger brother. It had four bedrooms, two baths and a nice screened-in porch. The price was a whopping $16,500!

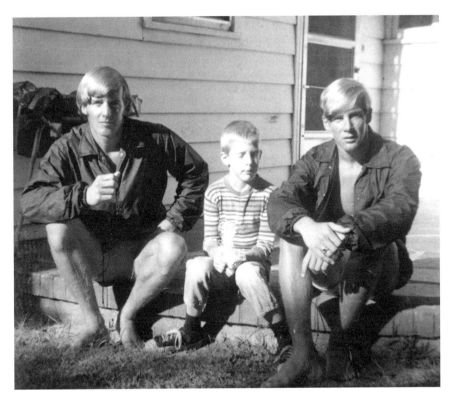

Jeff York, eighteen, on right with brothers Scotty, nineteen, and Casey, seven, at 106 Fletcher Avenue before going to lifeguard, July 1968. *Courtesy of Jeff York.*

I have wonderful memories of those early years growing up in Bradley Beach. We spent our summers on Second Avenue beach and in our little rowboat on Sylvan Lake. I remember going to the Palace Theater for twenty-five cents. We would often go to Mrs. Satzman's candy store on Main Street near Vic's. Candy was two for a penny. I can remember spending hours at Matty's 5 and 10 looking for the perfect toy to spend my ten-cent weekly allowance on. We would often go to the Francis Sweet Shop and play pinball machines. The owner didn't see well so he put red nail polish on all of his nickels so that he didn't mistake them for quarters.

I attended Bradley Beach Grammar School from 1955 to 1964. Over those years, I formed enduring friendships with the seventy-two members of my class. I can remember going to the Canteen that the Kiwanis Club held for the sixth to eighth graders in the gym each Friday evening. After that, we would all go to Vic's. I usually had one dollar to spend. That would get me half of a pizza and a soda. I can say that I am a much better tipper now than I was in those days.

Eighth grade was an exciting year for us. Our class was the first to visit President Kennedy's grave in Washington, D.C. He had been killed in the fall of our eighth grade year. We were also the first class to graduate from the new Ascension Center next to the school. Most of my classmates went on to Asbury Park High School. The school was on split session because Ocean Township High School had not yet opened.

Summers were spent on the beach and each evening we would go and hang out at the Penny Arcade on LaReine Avenue. We would often go across to the LaReine-Bradley Hotel to Mike & Lou's for a bag of French fries. I worked during the summer of 1966 at the Sand Bar on Second Avenue beach. During the summer of 1967, I worked at Vic's as part of the "pizza making team." I was responsible for putting the cheese and extra toppings on each pie.

In the summer of 1968, upon my graduation from APHS, I began lifeguarding each summer on the Bradley Beach beaches. I wound up doing that for the next twenty-seven summers. It was great to be out on the beach and in the rowboats all summer long. We also practiced hard for the different lifeguard tournaments. We had excellent teams and won many of the events.

In September of 1968, I began my studies at Monmouth College. I commuted from my family home at 106 Fletcher Lake Avenue. Aside from my classes, I was a member of the swim team there and worked part time at Sears in Neptune. I will never forget coming home from school one day in 1969 and finding our church, the Church of the Ascension, engulfed in flames. No one had any doubt that the elderly Monsignor O'Hara would live to see his beloved church restored to its former beauty, and he did.

After graduating from Monmouth College in 1973, I began a thirty-two-year teaching career at the Spring Lake Heights Elementary School. It was then that I finally left Bradley Beach to share a house with a friend in Belmar. I didn't stay away long, however. In 1974, I returned to Bradley to rent my own apartment at 1217 Ocean Avenue. I lived there until I purchased my first home. That home was at 106 Fletcher Lake Avenue, the house that I grew up in. At the time, my mother was living there alone. She wanted something smaller so I bought the home from her and she rented my apartment at 1217 Ocean Avenue. I lived there until 1993, when I sold the house and moved to Wall Township. The house at 106 will always have special meaning to me, as it was in our family for over thirty years.

I am retired now from teaching and spend my time between my homes in Fort Lauderdale, Florida, and Provincetown, Massachusetts, on Cape Cod. Bradley Beach was a magical place to grow up in the '50s and '60s. I imagine that it still is. Each time that I visit, the memories come flooding back when I come upon a house, a shop or a scene that was part of my childhood.

FATHER'S DAY

By Bette Blum

Blue flip-flops gallop
Dad carries bags from Virgil's
Red trunks and a hat

Walking to the beach
Baby carriage with beach chairs
Three blocks to the beach

Show the guard your badge
Check the tide and pick a spot
The lifeguards are near

Set the umbrella
Spread Sunscreen and Coppertone
On all the right spots

Small transistors sing
Talk to all the fishermen
Relax on chaise lounge

Ice cold lemonade
Pretzels, chips and purple plums
Lunch in wax paper

Read the airplane signs
Watch the half-day fishing boats
Glide to the inlet

Back to bungalow
Unload cooler from the beach
Then shower outside

Drive up to Mort's Port
Watch the lobsters in the tank
Fishing boats pass by

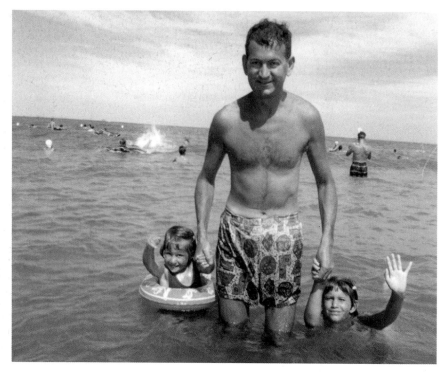

Bette, her father Louis Blum and sister Janet enjoying a beach day with dad. *Author's collection.*

Flounder, Jersey corn
Shirley Temples for the kids
Shark River sunset

Enjoy the front porch
Rocker, glider and hammock
Sea air through windows

Bradley Beach with Dad
Safe, Secure and Satisfied
Simply summertime

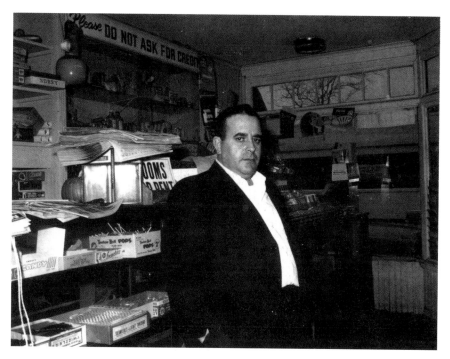

Virgil in his store. *Courtesy of Maryann Galassetti.*

VIRGIL'S

By Bette Blum, as told by Rose, Sal and Maryann Galassetti

Virgil's is what the good old days were all about. Virgil James Galassetti met his wife, Rose Stella Patane, at her Uncle Ralph's shoemaker store on Main Street in Bradley Beach (where Piancone's is located today). They were married in New York in 1952. They had two children, Maryann and Salvatore, and in the late '50s they opened the Maryann Shoppe on the corner of Newark and Central Avenues, one block south of Fletcher Lake, though everyone knew it as "Virgil's." Even some vendors called it Virgil's.

Virgil's wasn't just the corner grocery store. It was a gathering place and a staple in the center of a bustling neighborhood for many years. Friends like Harry, Soapy, Vic and Uncle Bobby Lee not only frequented the store, but also made it a warm and friendly meeting place. Rose remembered, "For a while the cops had to direct traffic outside, since the corner was so busy."

For years, the store was open from 7:00 a.m. until 2:00 a.m., seven days a week. It evolved from being a newspaper/cigarette/candy store to a grocery store with a soda fountain and pizza parlor and continued to change. Virgil saw what people needed so he added or took things away from the store year

after year. Virgil's carried fresh baked goods, candy, groceries and cigarettes, which they refused to sell to children. Virgil's even sold one-cent fish hooks to the kids who fished at Fletcher Lake. A variety of newspapers was outside with heavy rocks on top to keep them from blowing away.

During the days of the soda fountain, couples would come in at night on dates, sit in booths, order egg creams and lime rickies in frosted glasses, eat pizza and ice cream, play pinball and listen to their favorite tunes on the jukebox. Rose was excited to say, "It was like yesterday when Danny DeVito, who lived a few miles away, would pick up his date with his big black car and come into the store with his white shirt all rolled up to enjoy the delights of the soda fountain." He ran the rides in Asbury Park at the time and no one thought he'd be such a BIG Hollywood star. Virgil's also had visits from Shelley Bruce, who played the second "Annie" on Broadway.

Virgil would get up before dawn and go to Master's Bakery to buy at least five cases of kaiser rolls, also known as "hard rolls," along with dozens of raisin buns and crumb buns. "The rolls were still steaming when Daddy brought them into the store," Maryann recalled. Also, the customers would say, "Give me raisin buns from the center." They also demanded the ends of the crumb buns, as they were always the tastiest part. The milk came each day from Tuscan Dairy. They would carry cold cuts and customers would come in and order their meat "sliced thin" all the time.

Rose spoke with love of her neighbors, who were her best customers. "As for our neighbors, Chinese, Italian, Jewish, Irish, whatever, they became our family and we became theirs. We were all one, sharing times and helping each other out." She went on to explain, "Those times were not about where you went or what you wore; they were about the people you knew and how you spent your time. Not just being there but being there for your neighbor."

Virgil kept a drawer filled with keys from the neighbors, most of whom just came to the shore in the summer. If a neighbor had a plumber or electrician coming or needed their water turned on, Virgil had a key. The neighbors could always depend on Virgil for anything, as he was happy to help.

Virgil loved the kids in town. Not only did he teach the neighborhood kids how to make change and how to behave, but he also was the town's Santa Claus on several occasions. He wanted to please all of his customers all of the time. Virgil made sure he had their favorite newspapers. Outside on a blue wooden ledge he would have the *Asbury Park Press*, the *Newark News*, *Jersey Journal*, *Elizabeth Daily Journal*, the *Jewish Press*, *Il Progresso*, the *Forward*, the *Daily News*, the *New York Post*, the *New York Times* and the *Star-Ledger*.

He would even go out of his way to get the German papers for the German families who would stay up the block on Newark Avenue for a short

Rose with Virgil as Santa Claus at their store. *Courtesy of Maryann Galassetti.*

time during the summer. In the late '70s, there was a fire at the store and it had to remain closed for repairs. Sal and Maryann recalled that their dad would sit outside, probably in shock, with a cup in his hand and make sure his customers were all still able to buy their favorite paper.

Rose also remembered that when Virgil thought someone was hungry he would invite them into the store and make them a big sandwich. Rose added, "He would feed the world if he could."

The number one policy in the store was honesty. Virgil and Rose made sure Maryann and Sal knew right from wrong. One day a child came into the store with a twenty-dollar bill. He treated all his friends to candy and more. Though Virgil was glad to get the business, he knew it was odd for this child to have twenty dollars to spend so frivolously, especially back then. He went to the mother, who finally realized that her son had been taking her tip money to act like a big shot with his friends.

Sal was proud to say that his dad was always happy to help and that he would be sure people had what they really needed. Rose, Sal and Maryann each told the story that Virgil would write IOUs for folks who didn't have the money to pay for their entire order. When he passed away in 1983, there were still IOUs found in his wallet.

During the summer, men would order groceries ahead of time for the weekend. On Fridays, their wives would come in and pick up the order in time for the weekend with the family.

Virgil had to be sure that every family was satisfied. They even carried a larger variety of macaroni than ShopRite had in those days. The north end of Bradley Beach was heavily populated with Italian families from New York and parts of New Jersey, where it was a custom to make a large meal every Sunday for their entire extended family, and Virgil always knew what they needed.

There is also a Chinese population in Bradley Beach, mostly on Newark Avenue and Park Place. Many came from Chinatown in New York to spend summers at the Jersey Shore, away from the city. The Chinese men would often go fishing and Virgil would weigh their fish for them as they returned home from the beach.

Bradley also has a large Jewish population. Some of the religious men would pay for their groceries before the Sabbath and pick up their order on their way home from synagogue with their prayer shawls neatly wrapped under one arm, as it is forbidden to carry money on the Sabbath.

Rose was proud to say, "We went to our customers' funerals and weddings and they came to ours, as they were not just our neighbors and friends, they were more like family."

Maryann also loved to spend time with her summer friends who were just in Bradley for the season. She was always sad to see them go after Labor Day for the start of a new school year and recalled, "It wasn't as lively and there were not as many friends around in the winter." Maryann remembered that as soon as she could reach the cash register, standing on a milk carton, it was time for her to work in the store. She was probably about ten.

There was a penny candy case, when candy was really a penny, with the biggest variety of candy including all types of licorice, Jelly Royals, Mary Janes, candy necklaces, Bonomo Turkish Taffy, Squirrel Nuts, Frenchies, BB Bats, Tootsie Pops, watermelon slices, Juicy Fruit gum, Nik-L-Nips (wax bottles with juice inside), Red Hot Dollars, Kits, Pixie Stix, marshmallow ice cream cones, Bazooka bubble gum and even button candy on paper. Each day they would move yesterday's candy to the front and put the new candy in the back to be sure that the customer always would get a fresh serving.

Time after time, Maryann had to tell the customers, "Don't lean on the counter" as they began to pick and choose their favorite temptations. The customers would try to fill a #2 brown bag with as many delights as they had spare change for.

Maryann and Sal were busy working in the store when they were teens and didn't get to the beach as often as their friends. Sal recalled that he

Rose, Sal, Maryann and Virgil Galassetti at their store. *Courtesy of Maryann Galassetti.*

got to go to the beach for an hour in the afternoon, when business slowed down. Sal said his dad made time to go fishing with him, which he always enjoyed, even if it was a block away at Fletcher Lake. He also admitted that his dad taught him more than he could imagine about business and how to earn money the right way. Maryann agreed and added, "Our parents taught us the value of a dollar and that hard work brought stability, success and helped develop our character. We also learned that the customer was always right, to never talk back to the customer and we always did our best to satisfy them." Now Maryann is a principal and superintendent of schools and Sal is a successful chef.

Their family had to eat in shifts, as someone always had to be down at the store. Virgil would take a nap in the afternoon, shower and be down again at the store in the night. They hardly ever got to eat together as a family, but they spent a lot of quality time and interacted with each other all day long in the store.

Rose never really got to go to the beach, which was only two blocks away. But when July 12, her birthday, came along, she would proudly walk onto the beach, where her friends welcomed her with cheers.

Maryann knew her parents were strict, but that didn't hurt her or Sal a bit. "When we asked mom if we could do something she would always reply, 'we'll see,' which always ended up meaning 'no.'" One summer night, Maryann was asked out on a date by a young man in the neighborhood. Maryann told him he would have to get permission from her dad. So the young man went into the store and asked Virgil if he could take his daughter to a concert at Convention Hall in Asbury Park to see Frankie Valli and the Four Seasons. Virgil brought him back into the store where they kept the pretzel rods. He took one out and broke it and warned the young man that if he hurt his daughter, his fate would be that of the pretzel. He ended up taking Maryann to the concert, but so warned, never even held her hand.

So Virgil had a successful store for years. But more important, he had a busy, hardworking family, with a lot of heart, with a lot of love for each other and for the people in Bradley Beach.

Those were the good old days.

JOEL

By Naomi Bornstein Axelrod

I'll never forget my fifteenth summer! I had such terrible allergy attacks, one after the other. I suffered so, with swollen, tear-ridden eyes, a red nose and sheer exhaustion caused by sleep deprivation.

The doctor had just examined me for the second time that week. Ah, Dr. Levin; in 1958 he still made house calls! I could hear him speaking to my parents in the kitchen. He could not prescribe any stronger dosage of medication, and told my parents they needed to take me to a place called Long Beach Island, where there were no trees or pollen to speak of. That would be the only way I could get relief.

So early the next morning, my parents, my sister Ronnie and I piled into the car and headed "down the shore." I was somewhat excited. I have always loved the ocean; I am a Pisces, after all. We drove and drove, and slowly all the green was disappearing before my very eyes. I longed to see a tree, and wanted to go back to Pleasantdale, in West Orange, where we lived. We finally arrived in Long Beach Island, and when we got out of the car I started to cry. It was like the floodgates opened. It was barren; all I could see was brown, sand, clapboard houses and to add to the dismal scene, there was no sun shining that day.

I told my parents I would not stay there; I didn't care what the doctor said. It was in the middle of nowhere, and I didn't hear or see any children of any age. I cried and cried. Finally, my parents decided we would head back north,

to a place called Bradley Beach. I agreed, and we started on our journey. Now I have to tell you, I did not rule the roost in our house by any stretch of the imagination. The fact that my parents were willing to go someplace else should give you a clue of what we saw that day. It was quite depressing.

We arrived in Bradley Beach and I started to smile again. I saw the boardwalk with people, lots of kids in the Penny Arcade and could hear laughter. We took a room in the LaReine-Bradley Hotel for one week, until Labor Day, and I felt so much better being in the salt air. The following year, my parents found a bungalow to rent for the month of August on Ocean Park Avenue, and that is where we stayed until Labor Day.

The first day there, I met a girl my age who was staying with her grandmother for the summer. Judy Nemetz and I quickly became fast friends. She took me to the pavilion on Friday night for a teenage dance and introduced me to her friends. I saw a boy my age sitting on the railing talking to the band members, and immediately fell in love. He had beautiful hazel eyes, dark brown hair and a smile that could melt your heart. Judy introduced me to Joel and his twin brother, Stuart. Joel asked me to dance, and they were playing "Rock'n Robin." He was such a good dancer. We danced several more times that evening. The next day it was raining and we could not go to the beach, so Judy and I went to the Penny Arcade, which was filled with teenagers.

Joel and Stuart were there, and we started to talk, and made plans to walk into Asbury Park via the boardwalk that evening. There were about ten of us, not dating, just boys and girls having fun together. From that point on, we spent every day on the beach together, and evenings found us either at teenage dances, at Mike & Lou's or Syd's, having a hot dog or a soda. It was a wonderful time, and I felt so much better.

Labor Day came, and with it came the end of our summer romance. Joel lived in Elizabeth, and I lived in West Orange. Neither one of us drove, since we were only fifteen years old. Joel did call me a few times over the next few months, and then he invited me to a New Year's Eve party at his friend's sister's house. My parents said I could go, and they drove me to Rahway, where Stuart's girlfriend Sheila lived. I slept at Sheila's house, and my parents picked me up the next day. Once again, Joel and I kept the phone lines busy.

My parents, meanwhile, had decided to go to Bradley Beach for the entire summer, thinking it was good for me. They rented a bungalow on Brinley Avenue, and once school was out we headed for Bradley Beach. I drove my graduation present down: a 1954 powder blue Chevrolet Bel Air convertible. It was five years old when I got it, but I didn't care that it was used. I loved that car!

Joel was also down in Bradley Beach for the summer, as his parents had also rented a bungalow. So we had a wonderful summer together, swimming, going to the boardwalk and dances. We just enjoyed being together. The summer passed by very quickly, and before we realized, it was Labor Day.

We were no longer children; Joel started college, and I started working. We saw each other on New Year's Eve, and then Joel and Stuart enlisted in the air force. Joel dated others, and so did I. Occasionally I would get a letter from him. I haunted the mailman every day, anxious to get mail.

Our on-again, off-again romance really took hold when Joel received his discharge from the air force. We were engaged, and married in 1966. Judy Nemetz, who had introduced us, was one of my bridesmaids. We lived in Verona for a year, and then moved to Matawan and lived there for several years. Jeffrey was born in 1969, and Rick was born in 1972.

Joel was then working in Eatontown, so we were able to make the move we had wanted to. We bought our first house on Monmouth Avenue in Bradley Beach. The years were kind to us; Joel's hazel eyes were then covered by glasses, the dark hair was graying at the temples and thinned out somewhat. We no longer had the lithe bodies we once had, but we were so happy.

Joel was elected to the board of education, and I was active in the PTA. Joel was president of the Men's Club at our synagogue, and I was president of the Ladies Auxiliary. We loved Bradley Beach, but as the boys were getting older, we knew we had to leave our beloved town.

There were several reasons: we did not want to send the boys to school out of town; we were looking to join a conservative synagogue so the boys could start attending Hebrew school; and we felt that rather than putting a lot of money into our eighty-plus-year-old house, we would be better off getting something more modern.

So we moved to Ocean Township. This was near enough to still enjoy everything that Bradley Beach had to offer, including some dear friends. I lost my darling Joel too soon; he was only fifty-two, and suffered a massive heart attack. He will be forever young in my mind and heart. We dedicated a bench in his honor on the boardwalk in Bradley Beach, and it sits on the spot where we met.

Even though Joel left us at an early age, I know how lucky I was. We had a special marriage, the envy of many people I knew. We were best friends and stayed best friends after we married. I have sold my house in Ocean Township, and am looking to move into something smaller on one floor. Who knows? I may even return to Bradley Beach.

Marc Schwartz and his Grampa Joe Heimberg. *Courtesy of Marc Schwartz.*

ME AND MY "GRAMPA" JOE

By Marc Alan Schwartz

My memories as a kid down the shore are forever linked to my grandfather (my mom's dad). Grampa Joe and Nanna Mary lived in Union and would come to Bradley Beach maybe two or three times during the summer. This was always a special treat for me, as I was close with my grampa. I later learned when doing a family tree history project that Joe cared for my brothers and me during my mom's recovery from a serious operation after I was born.

I was Joe's favorite grandson and we had the same look, right down to his white hair. When my grandparents came to visit, Joe would always stop at the Avon Bakery or at Master's Bakery on Main Street in Bradley for a seven-layer cake or chocolate éclairs. The seven-layer cake was absolutely delicious and to this day, I have yet to taste any layer cake that could hold a candle to the cake of my youth. The cake would last for a few days in the refrigerator and with a cold glass of milk, we had our late night snack covered.

Joe and Mary would never step onto the beach. They preferred to sit on the bench seats on the boardwalk, where I would sit with them and talk about whatever was on my mind. My grampa was a man of few words (much like I am), and so we often just sat together in silence and watched the activity on the beach. Joe was a Yankee fan his entire life. He watched or listened to most of the games all summer and we could talk about our beloved Yankees at any time. I was amazed that Joe never attended a game at Yankee Stadium his whole life. Joe always had that supplemental allowance for me (I think it was two dollars), which was really special. With two dollars in hand you could go to the arcade that night. Years later, I would work an entire hour at a part-time job for the same two dollars.

My grampa always had impeccably shined shoes and wore a tie, even though he was retired and it was summer. He also liked to play cards with my brothers and me. The game we loved to play at the time was casino. He was a sly player and often left the ten out on the table for a few passes before picking it up with the ten of diamonds for the big points. Casino players know what I am talking about. I'm sorry that I didn't have the patience at the time to learn pinochle from Joe, as that was his favorite game. As for Nanna Mary, she would always ask me about the girls that I was not going out with. It seemed if we only listened to our grandparents and followed their advice, we would have been spared some teenage angst and enjoyed our summers more. Every so often when I walk the boards in Bradley (now a wide brick walkway), I envision those early days and see my grandparents wave to me from the pavilion. It is a memory of the shore that I will always look back on fondly.

TRUE LOVE

By Florence Silverman Berman
While living in Newark during the summer of 1951, a friend and I, both young, working adults, decided to visit my mother, Jeanette Sternig, and spend the day on the beach at Bradley Beach.

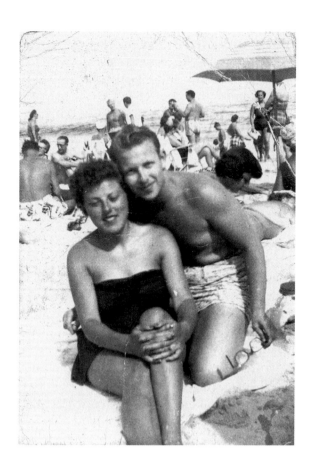

Florence and David
Silverman. *Courtesy of
Silverman family collection.*

After changing into our swimsuits, we strolled on the boardwalk when we
spotted my friend's tenant, who was living in an apartment above hers. We
decided to join her and lo and behold, there was my future husband, her
brother, David Silverman.

There must have been an instant attraction, because he asked for a date
that evening. I accepted. I didn't like him much on the beach, but during
the evening I was drawn to him. During the following two weeks, we were
together constantly, and we knew we had found true love.

We were married on September 6, 1951. My husband was in the army,
home on furlough when we met, and was under orders to return to his outfit
in Germany, which he did. I joined him there on Valentine's Day, 1952.
Several years later, he was ordered to France. My oldest son, Skipp, was a
toddler at the time. Upon my husband's discharge, he became a hairdresser.
He was offered a job in Long Branch at Tony's House of Beautiful in West
End, which is still there. David then opened up his first salon, David's of
West End, right around the corner from Tony's.

We settled in Bradley Beach, where my husband opened David's of West End #2 on Main Street, where he worked for eleven years. My sons Skipp and Paul grew up in Bradley Beach and enjoyed a happy life there with many friends.

Even now, so many wonderful memories of Bradley Beach come floating back to me.

BOY, DO I MISS THOSE DAYS

By Lila Barsky

Bradley Beach was our summer home for many, many years. We were stuck in an apartment in Irvington with two children, so the day the school year ended, we drove right down to Bradley Beach and spent the entire summer there until the day before Labor Day.

My husband came down on the weekends. We rented part of the house with my sister and her family. Our landlady was our mother hen for at least ten years. Every morning, seven days a week, we shopped and hung around. After lunch we would hit the beach. Oy, when it rained we went to the movies on Main Street and sometimes even ventured into Asbury Park for big-time pictures.

No sand was allowed in our house. We had a little shed with a shower outside. When we came home from the beach, we showered and dressed in these dingy quarters, but it always kept our house nice and clean. We ate outside a lot and had many barbecues and picnics. We played mah-jongg, cards and always had the greatest times.

Our kids loved every minute of our summer vacation in Bradley Beach, until they grew into adults and the novelty wore off.

Boy, do I miss those days and boy, did we have fun!

A LASTING FRIENDSHIP

By Gladys Gordon Blum

In our early teens our gang at the shore liked to meet about 11:00 a.m. every day at the beach. I usually slept until 10:00 a.m. and always had chores to do before I left the house.

A friend who also summered at Bradley Beach would come by for me about 10:30 a.m. and, seeing I wasn't ready again, it was almost routine for her to help me with dishes, beds and more. Without her help I would have been late for "just meeting friends and hanging out" many times. She always knew how much I appreciated her help.

We were friends in grade school in Newark, friends in Bradley Beach and we also double-dated with Bradley Beach fellows together. We never married the boys from Bradley Beach, but we did attend each other's weddings and many family Simchas over the years. Today, sixty-plus years later, Marcia and I are still good friends.

A friend in Bradley Beach is a friend for life.

MARTY

By Rich Weissman

My father Marty would have been in his eighties now, but cancer took him in 1996. And, as with most things in my life, my memories of him have a distinct Bradley Beach flavor. This is the person who taught me to swim (in a way that I taught my kids), taught me to fish and also taught me how to take care of my family.

He and my mother scrimped and saved so we could go "down the shore" in the summer. I never quite understood how expensive things were, as it was always kept from me. I thought ALL kids went to the beach for their summers. Little did I know.

My father was always in the cleaning business, and for many years he drove a truck on a route through Elizabeth, Union, Linden, Roselle Park and Newark, servicing the neighborhood tailor shops. That was certainly a time that has gone by. His hours were early, leaving our home in Elizabeth by four o'clock each morning and returning home mid-afternoon. Not an easy job.

It was worse in the summer. He would stay in Bradley Beach with us and leave for Irvington around 3:30 a.m., do his route and return to the shore about 3:00 p.m. He'd come to the beach and take a nap, and then go swimming. A long day for sure, but I kept my eyes peeled on the boardwalk at Fifth Avenue waiting for him.

This went on day after day all summer, except for his two-week vacation. Never did I hear him complain about the extra hours on the road, the traffic or the wear and tear on him. I'd thought it was the love of the shore that drove him.

When I got older I realized that it was the love of his family that drove him.

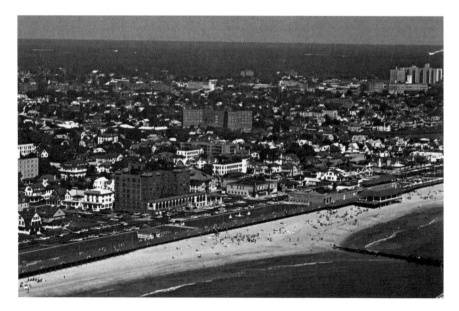

View of Bradley Beach and LaReine Hotel. *Author's collection.*

LaReine Hotel Pool

By Ron Rosen

My parents bought a four-bedroom bungalow with my aunt and uncle in 1948, when I was six years old. The house was located at 102 LaReine Avenue. For two years prior to that, they rented on LaReine Avenue, five blocks from the ocean, across the street from the church. (Lots of bells on Sunday morning.)

I remember walking next to the carriage in which my cousin Joyce sat. She was three years younger and couldn't object to the blanket, chairs, thermos, pails and shovels that were piled on top of her as we trekked five blocks to the beach for the day. Joyce's brother Sanford, eight years older, escorted us and acted as a big brother.

After two years of rentals, the bungalow was bought. The price was $7,500 (as I learned when I handled the closing in 1976) for a four-bedroom house almost across the street from the beach and ocean. Next to us was an empty lot that was to become the Sand Bar Restaurant. We were across the street from the LaReine Hotel, and had a great view of the hotel's porch and all of the guests.

Our house had no insulation in the walls, no heat and certainly no air conditioning. To be cool, one only had to open a few windows and get the breeze from the ocean. It seemed as if everyone who went to the beach

during the day, or to the boardwalk in the evening, passed our house. As a child I roamed the streets unattended. Joyce walked to Doc's for the morning *Newark Star Ledger*, while I walked to Ruskin's store for rolls, some lox and breakfast items. For the big orders, we all went to Bleemer's or the Newark food market.

At night everyone in town went to the boardwalk. The kids went to the Pokerino, where Benny manned the cash register and George gave out coupons, change and fixed the machines. The adults sat on the benches and talked in the cool summer evenings in Asbury Park and even Seaside Heights on the weekends, when the dads came down. That was a treat. Dinners during the week for special times were at the Miamian or Mrs. Jay's in Asbury Park.

As a young teenager, I went to the pavilion at Ocean Park Avenue and boardwalk to attend the dances. Younger kids went early and older kids later. Nan Giller and Fritzy Cooper ran the summer's activities. Nan Giller also ran the Sand Bar, and later ran the Second Avenue Snack Bar with her husband, Moe Giller.

My first summer job was as a pool boy at the LaReine Hotel, with Sandy Zweben (the owners' son) as the lifeguard. The following year I was the lifeguard, and Sandy went to work in the kitchen as an assistant to Sam, the salad man. I then became a busboy in the dining room and then a waiter. Sandy became an assistant steward and then in charge. Mr. Isaacson (Mr. I) was the real head of the kitchen, and Myron Weiner was the maitre d' of the dining room. I learned as a pool boy about the mat room in the basement of the hotel. That was where we stored the chaise lounge mats when not in use. It was a room full of mattresses. What could be better for dating, if one got lucky?

In my late teens, it was hanging out at Mike & Lou's and Syd's Hot Dogs. Mike & Lou's was a bigger hangout, but Syd's had better hot dogs. I spent a lot of my free time, between serving lunch and dinner at the hotel, at the miniature golf course, where I sat with Ellen Sue Konner (now Hirshfield), the owner's daughter.

When I became eighteen, I took my restaurant talents to the Catskill Mountains, where the same work produced more tips. After my Weequahic High School prom, where do you think we all went on Sunday? Guess no more: Bradley Beach.

Bradley Beach was a happy time. School was out, and relaxation was the order of the day. Labor Day was always miserable. Friendships were parted and we all went our own ways, back to Newark, Irvington, Hillside, Maplewood, etc.

I'm sorry the house, which still stands, was sold by my family. I have great memories.

GROWING UP IN BRADLEY BEACH

By Skipp Silverman

My life in Bradley Beach began in 1963. I was six and in first grade, living on Fifth Avenue one block from the beach. Who knew I was destined to be the equivalent of a West Coast surfer dude on the East Coast? My friends were there, the BENNYs from the "burbs" of North Jersey.

Everybody knew me as a Casanova, very friendly, outgoing and always bringing new friends together at the beach on Brinley Avenue and the surfing beach. My dad was the local hairdresser, doing the hair of many friends' mothers and grandmothers who wanted to fix me up with their daughters or granddaughters, most of whom I already knew.

My life has many stories with all of my friends from up north. My highlights though are my first kiss, my best friends being a tight group of four, doing magic shows to entertain, hanging out together day after day on the beach, playing jokes on each other and going to the Penny Arcade every night of the summer.

Her name was Cindy. Her family lived next door. They were always down from Memorial Day until Labor Day. She was my first girlfriend, my first bud. We built forts in the backyard, went to the beach, dances, the LaReine Avenue Pavilion, got ice cream many times and went to Mike & Lou's.

One day it was rainy and we made a fort out of some heavy tarp. We threw it over the clothesline and made a small hideaway with a few two by fours. It started to rain and we went inside, close to each other. The next thing I knew, Cindy kissed me and I was in love. We were eight years old. After that summer Cindy's parents sold the house.

Long before there were cell phones and pagers there were the pay phones. Who knew they could act as paging devices and for leaving messages? It was the summer of '73, another typical evening at the boardwalk. People were moving aimlessly, enjoying the warm summer night. The sun was slowly setting over the west. All of a sudden, a ringing noise stirred in the crowd. Curiosity allowed the ringing to persist a few more times. Someone finally answered the pay phone. It was a female voice on the other end. She asked if Alan was there; it was his mother. The person on the phone was yelling for Alan. He was one of my best friends, so I went looking for him. She was holding for him at the pay phone next to the Penny Arcade. "Alan, your mom's on the phone." He was there, but a bit embarrassed.

Good thing not all of our mothers had that number!

A State of Mind

By Marge Tsang

Everything about Bradley Beach, for me, was a special revelation. You see, I'm a city girl, originally born in Queens, New York. Public school, subway and "el" rider and of Chinese heritage. I was carefully taught to respect family and elders and the proper ways of conducting one's journey throughout one's pursuits.

My world was carefully small. But then, a weekend at my husband Tim's grandmother's, and the Church of All Nations Camp was a whole new experience. There were Chinese-American families that lived in their own cottages and homes, scattered among the Italian, Irish and Jewish families. All were compatible beachcombers. Guys fished off the jetty or in their fishing boats, sharing their catch. Everyone seemed so friendly and warm. I thought, this is truly the American dream happening, because we are in a good place in this good moment. That nice feeling has lasted a long, long time.

Tim's mom bought her own cottage. We enjoyed many a weekend down at the waves' edge, and our grandchildren, far-flung, almost all grown now, can smile. The memory of the beach and waves is nostalgia that brings to mind pleasure and relaxation. That's Bradley, thank you. Good people, good families of Bradley Beach.

I live in Clifton in the wintertime. It can be mild or fierce, and I wonder how our little Bradley cottage is doing, especially during the windy, awful weather. I collect gloves, brooms, mops, soaps and cleaning buckets. The staples are bought in duplicates, an accumulation of Bradley-intended things, and a funny clutter waits on the landscape. These things have a way of saying, "Take me, I can be used in Bradley." When I see and buy a thingamajig for Bradley a certain trend occurs, and a Bradley feeling starts to grow when I am busy with routine chores, Bradley suddenly pops up, welcoming the anticipation of change and the promise of summer.

Old friends would remember to ask, "Is Bradley still OK?" That particular query is really asked about the way of life, as it was, many years back, reminiscing about the hot lazy days on the beach, the sound of the waves, the distant murmur of children at play. One just luxuriated in the pleasure of semi-dozing. All seemed so far away. Then the sudden hunger, time to go home for quick showers, food or sleepiness. Which to satisfy? Showers win. The meal tastes better than expected.

And then, in those good old days we would walk to Asbury Park. The wonderful wooden planks of the boardwalk were so easy on the legs and the knees. The soft breeze as one lingered at the railings. Look out over the

waves. Oh, the smells of the sea and the ocean…a feeling of oneness with the stars, the moon and then continue through quaint Ocean Grove. The charm of the quiet dignity of Ocean Grove is still attractive to this very day.

Suddenly it was there, all in front of us; the boardwalk had led us to the carousel. The strong, loud organ music was greeting families. Children choosing their colorful mounts. The lovers, shyly smiling their approval for each other, hardly caring which horse they were on. Just "being there" was nice. And then, more walking, we notice the strollers as the young persons enjoyed the gazes, in return admiring, truly a promenade. The rides were the big attraction. Heads turned following the gleeful screaming of the roller coaster, the smaller versions enjoyed by the small fry.

Attentive parents were on standby, waving in reassurance as each circled round repeating a ritual that once their parents had done with them. The promise of ice cream cones lured the kiddies off…the walk back home… happy satisfaction…happy dreams. And tomorrow the beach, wonderful sandcastles, wet sand, delicious snacks, chasing waves and doing "nothing," just "nothing" and doing "nothing" with the very people you like doing "nothing" with. So comfortable, so safe, so natural. That was Bradley Beach then.

Of course there were the movies, the dates, the hot dogs, soft ice cream, the taffy, the hunt for parking spaces, the warmth of the neighbors greeting each year as one walked to and fro; it all goes to that "state of mind" that was Bradley Beach.

And now, much has changed. Our friends are shocked to see the ruins of the carousel. The sad lady of Asbury Park, a glimpse of the Stone Pony, reminders of past busyness. It has been suggested that a new group of people will revive, renew Asbury Park to a happier town. I hope so; again, it will be a place to walk to.

Today, there is a stirring, a sense that Bradley Beach is building anew. Things look perky, fresh. The beach has survived hurricane after hurricane these many years. Newly mounded dunes, with their strands of sea grasses, poetic beauty. Far sky, smell of sea, hear the gulls, the waves and you are there!

Bradley Beach. Memories. Happiness again. It is all welcome, this state of mind. Come, join me and relax…it's Bradley.

Part Two:

Fun and Games

Pinball Fever Thirty Years Later

By Karen Usatine

I was at a party in San Francisco the day after Thanksgiving. A gathering of diverse adults from all over the country who chose the San Francisco Bay Area as home, we carry on holiday traditions with friends who become family over time. My friend John has an old Gottlieb's pinball machine in his dining room, a soccer theme. I couldn't remember when I last played one of the old games from the 1960s or '70s era. You may know the kind: five balls each game, numbers spinning around as your score adds up, nothing digital in sight.

Stuffed with too much food for the second day in a row, we played in groups of four. As I watched the first group a strange thing happened. I felt awash in physical sensations as the old fever came over me. Memories of Bradley Beach and the Penny Arcade flooded my mind and transported me to my East Coast adolescence. I tried to describe to those clustered around the machine what my summers were like at the Jersey Shore. Of course it was clear that they could never fully understand. You had to BE THERE. It was unique, the time, the place, the people. Or so it seems.

We were too young to venture far from home at night. We were old enough in the late '60s and '70s to walk a few blocks to the Penny Arcade on the boardwalk in Bradley Beach. Unchaperoned by parents, we gathered nightly, with quarters jingling in our pockets. The damp, sandy, gritty cement floor, row after row of pinball machines and assorted games. The

counter with plastic toys displayed, stuffed animals and prizes exchanged for tickets won in skeeball. Pinball heaven to a child; the salt air, the ocean pounding the beach just outside the front door. Jay was the ever-present manager of the Penny Arcade at LaReine and Ocean Avenues on the wood-planked boardwalk.

Did he own all those games, or just manage the arcade; did he sleep in a room in the back, or have a real home; was he a summer person, or a townie? I never asked those questions. He was just there, just Jay, and he was mostly a nice guy. He was a parental figure of sorts, being one of the few adults in the arcade. He shouted at us if we got too rowdy or banged on the glass tops of the machines. He was stuck with us, and we him. I think it was a love/hate relationship. We needed each other. He was the giver of change, he exchanged our precious tickets for cheap trinkets we called treasures. He chased us out at closing time. We could never get enough.

In San Francisco, at forty-six years old, I looked that machine over like a pro before getting into the action. Five balls, okay. Where were the high-scoring bumpers, holes, and how many flippers were there? And then there was the most important question I had to ask before playing. "How hard can I shake the machine before it will tilt?" You see, I always played the game with my whole body, even when I weighed under one hundred pounds. I never used just my hands and fingers, passively watching the ball bounce around randomly, waiting for it to hit the flippers. I loved to shake the machine, create some of the action. My friend Eji said she used to play at home in Ethiopia, and she thought it was all luck, no skill. I strongly disagreed. The more I shook the machine, reflexively kicking one foot behind me, putting all my body weight into it, the more control I had over it. Decades of adulthood without playing pinball didn't matter. I had racked up countless hours from the age of ten to sixteen, when driving a car widened my choice of entertainment and made the arcade less compelling to an adolescent in search of new adventures.

In a living room in San Francisco, with the Pacific Ocean pounding the beach only blocks away, I had the fever again. I played like the young girl in the Penny Arcade on the boardwalk in Bradley Beach, New Jersey. My body, mind and spirit were fully engaged, loving every flip of the flipper, every ca-ching of the bumpers hit by the ball. As John watched, I explained how I used to play every night, endless hours. He said he could tell by the way I handled the flippers. I was proud that my old skills were visible to a trained eye. In the first game against the other three players I got the highest score, over 25,000, way ahead of the competition.

But that wasn't as important as the knowledge that it was all still there: the intimacy of the game, the excitement, the dance, the fever. I could shake

that machine, yell and scream, curse when I lost a ball, put my whole self into the competition between the machine and me. I was on fire, and the possibility that it was only a game of luck was out of the question. I played over and over until it was time to let others have a turn. With a few parting tips to the neophytes, I retired to the other side of the apartment to calm down. The adrenaline in my body took me back to my teens and I was in heaven. Then the reality of my aging body took over. I lay down and closed my eyes. I needed to rest from the dance with the machine, my old friend.

Pinball fever. Yes. I think those of us who fell under its spell in those early years at the Jersey Shore will always be susceptible. One game for a dime, three games for a quarter, five balls each game. We took it for granted, the possibility to play all night for a couple of dollars. We won free games on our favorite machines, whose nuances we spent hours memorizing. Leaning into them, shouting at them, shaking them. Like old friends, they stood by us, they waited for our return and we danced the pinball dance. They complied and resisted as we shook them with all our strength. We felt safe. We had Jay and our friends and siblings nearby. Home was a short walk away. The streets felt safe, the night smelled salty. Each day we were assured by the knowledge that after a day at the beach, a shower and dinner with the family, another night at the boardwalk awaited. The arcade, the Penny Arcade. LaReine and Ocean Avenues on the boardwalk. Pinball heaven was waiting.

LOVE AT FIRST SIGHT

By Barbara Wigler Dinnerman

I was born and raised in Newark, New Jersey, and all of my childhood summers were spent down the shore in Bradley Beach. They were wonderful. My early teenage years were in the 1940s and it was wartime. I remember that the boardwalk lights were painted black on the sides that faced the ocean. This gave us all a sense of security. Every night the dimly lit boards reminded us that our nation was at war.

I remember walking the boards to Asbury Park Convention Hall and seeing some of the big bands and singers, like Vaughn Monroe and Dick Haynes. Afterward, we would come back to Mike & Lou's great hamburger and hot dog stand on the street under the LaReine-Bradley Hotel. They had the best hot dogs! It was a favorite hangout of ours, listening to the jukebox and just having good old fun.

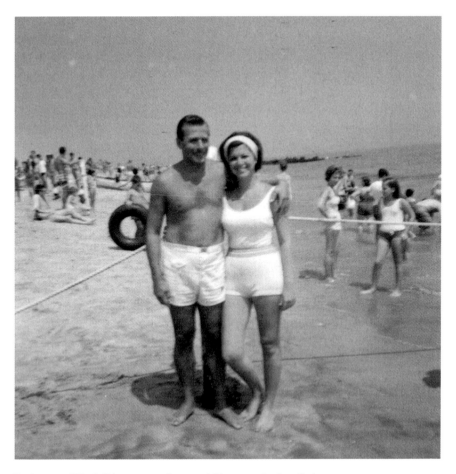

Barbara and Herb Dinnerman. *Courtesy of Dinnerman family collection.*

As a young adult, I still went to Bradley Beach for the summer. On McCabe Avenue beach I even met my second husband. It was love at first sight. We married a few months later and continued going to the shore and renting the same bungalow year after year. What wonderful years they were!

There were Wednesday night dances at the LaReine Avenue pavilion, the greatest rolls from Master's Bakery on Main Street and the best pizza and Italian food at Vic's, also on Main Street. I even taught my daughter to drive when she was sixteen at Evergreen Avenue and Sylvan Lake.

Bradley Beach will always hold the most precious memories for me. My husband has passed away, and yet when I return to Bradley as I did this summer, I smile and hold dear to me all the wonderful and happy times we had there.

The boardwalk now has pavers, there are condos along the ocean where the old hotels used to be and the beach has sand dunes. However, the smell of the shore is still there. My bungalow is also there, with exterior and interior changes, but it is still there. Life was pure and sweet back then and I will always have my memories of that bygone era to treasure forever.

MY MEMORIES OF BRADLEY BEACH

By Richard Roth

Around the turn of the century, my grandfather, Philip Fenster, built three bungalows in Bradley Beach. One of these was located at 411 Ocean Park Avenue. This is the one where my family spent summers from the time I was born until I was drafted into the U.S. Army. I spent eighteen summers there from 1927 to 1945. Here are some of the places I remember:

Newark Avenue stores; Wooley's Fish and Ice Dock; Shatzow's Appetizers and Grocery; Bleemer's Kosher Butcher; Mendel's (S & S) Vegetable Market; Ralph's Barber Shop; Butler's A&P; Schwarz Drug Store; Vic's Pizza; the Palace Theatre; Mom's Kitchen (across the railroad tracks); the Lake and Sea Hotel; the LaReine Hotel; Mike & Lou's; Fletcher Lake; Ma Tischler's Rooming House; Janet House; Roth's Novelty Store; the Bingo; the Penny Arcade; the kiddie rides; miniature golf.

Some more memories: the Hindenburg flying over our bungalow in the summer of 1936 on the way to Lakehurst; the luxury ocean liner the *Morrow Castle* sinking just off the shore between Asbury Park and Bradley Beach in 1934—I was only seven years old but never forgot the sight; bathing badges were made of metal and a swimmer was struck by lightning so later they changed them to plastic—I believe it cost $1 for a season badge then; our walks to Asbury Park—we walked through Ocean Grove and ate at the wonderful Homestead Restaurant, where a full fried chicken dinner was $1.95 and you sat overlooking the ocean; Zad the artist drawing a portrait of any subject for $2; the hawkers demonstrating the newest kitchen gadget; the Palace, with the funhouse and giant ferris wheel; boat rides on Sunset Lake; James' Taffy Shops, and Mrs. Jay's; Asbury's most beautiful movie houses in the country, including the St. James, the Paramount and the Mayfair; Frank Sinatra signing autographs at the music store when he was just starting out in his career; the Popsicle stick games under the boardwalk; the "cookalanes" where people would share a kitchen, a table and a refrigerator and somehow get along.

To this day I often ride down the shore and pass our old bungalow to bring back memories of the wonderful times we had there. The nostalgia is

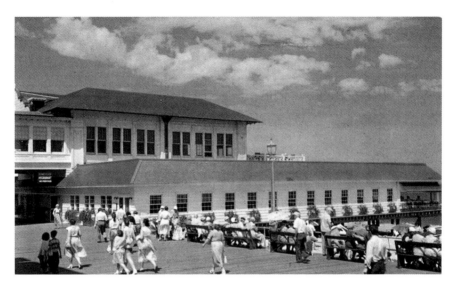

Homestead Restaurant, Ocean Grove. *Author's collection.*

impossible to describe. It was a unique time in our lives. The beaches, the ocean and the people were so much fun. I don't think we'll ever see times like that again.

ECHO OF A SUMMER NIGHT

By Mark Jacobs

Echo of a summer night
The forever week is over and the work whistle sounds
No time to shower as the Charger's horn is blown
Laz, Chaz and Billy greet me with grins
The air conditioner dies, the windows roll down,
the heat and fumes rush in
It's the parkway bump and grind but we don't mind
The red Mustang passes off a joint
The eight-track blasts "White Room"
Exit 100 can't come soon enough
We make our way to the North Lodge
Five dollars apiece brings grand accommodations
Mattresses on the attic floor

We stow our gear and go off to Vic's
Green peppers and sausage pizza
Our hunger partially abated
We make our way to the boardwalk and play
Lucky Seven in the arcade
The girls leave their summer homes under watchful eyes
Some are waiting for their summer weekend guys
Harley and her magnificent grin
She is with her friend Susan and her painted-on jeans
On the beach Bette and Pola have Chaz and
Billy playing their guitars
"Stairway to Heaven" mingles with the crashing
of the waves on the jetties
Beneath the boardwalk it's strictly rock and roll
The innocents above talking softly and holding hands
As the night concludes and the watchful eyes wait for their return
Whispered goodbyes and hush falls over the misty shore
Waiting for tomorrow when the beach at LaReine calls

BRADLEY BEACH CHILDHOOD

By Charlotte Lowitz Tucker

Our house was on Fifth and Central. I remember my father making me swim to the ropes at the age of five. I lost ten pounds one summer because I stayed in the ocean all day long and only came out to eat. I think I grew an inch that summer too.

I never could figure out how my mother managed to cook for about fourteen people, three times a day, with a small refrigerator. She never left the kitchen. She was Philip Roth's mother's friend and they sat in the pavilion at the LaReine Arms with their umbrellas when they had the time.

I was very good at skeeball at the Penny Arcade. I also learned to shoot pool at the age of nine at my friend Billie's house near Ocean Grove.

The traffic on the parkway, down to the shore, was so awful that my older sisters taught me to play Ghost, a word game, to pass the time in the slow traffic.

Now I live in Florida in the winter, directly facing the ocean—because of my Bradley Beach memories.

Summer Lovin'

By Ronnie Bornstein-Walerzak

Back in the '60s a singing group called the Happenings had a song called "See You In September." It was about being apart from your significant other for the summer and meeting someone new and having a summer fling. Remember those?

I can remember back to my very first official date. It was the summer of 1958 in Bradley Beach. I was all of nine years old. All the adults used to set up their beach chairs in a circle, wagon train–like. They would have the smaller children inside the circle so they could watch over them and us "older" kids had free reign of the beach. Times were different then! Parents knew if a child got lost it was only a matter of time before all the lifeguard whistles went off to show a scared child standing atop the lifeguard chair, waiting for mommy or daddy to claim him.

Our adult group had many of the same people every weekend. All week long the moms had a small circle and on the weekends the dads would be there to enlarge the group. This one particular weekend, a family that was visiting from up north joined for the week. They were relatives of "regular" members, so they just fit right in. They had a son; it seems it was all arranged even before I knew he existed. He was very shy, two years younger and at least a head shorter than me, but well, we were only seven and nine! It was planned that Steven and his dad would come a-callin' for me at a specific time and we would walk to the miniature golf course on the boardwalk. As much as I loved miniature golf, I was not happy about this at all…eww he was a BOY! But alas, I had no choice.

So I had to put on my very special sundress, flats and little white cotton gloves. (This was proper dress for kids back then.) He even had a little suit on, with a tie and all! It was a warm summer evening and this poor kid had to wear a jacket and tie. He must still have nightmares from that evening. I went along to play golf. It happened that everyone else in Bradley Beach was also there to play golf that same night. My regular friends were the first hecklers I ever met. They not only called out unkind comments, but made a spectacle of themselves among the crowded golf course until they were "asked" to leave. It was such an unpleasant experience. It reached its pinnacle when I made a hole in one on the eighteenth hole and won a free game to be played in the future. Don't forget I had this game perfected from my many excursions there throughout the summer. Well, this was more than Steven could bear; he became hysterical, crying, actually throwing a tantrum! I quickly offered my free game coupon to him as a calming technique. It worked!

We finished the wonderful date with an ice cream cone for the walk home. Ice cream cones and white gloves do not mix; need I say more? All in all it was an experience I never forgave my parents for and it would be five more years before I dated anyone at the shore again. This time my date was my choice, and we had our dates at the beach, the arcade, Beach Cinema, the Bunny Hop or Vic's. But never once did we play miniature golf!

I REMEMBER WHEN

By Gladys Gordon Blum

I have spent the past seventy summers in Bradley Beach—it is part of my life. So sit back, relax and join me as "I remember when"...the simple things of life mattered most. We were very lucky to spend our childhood summers in Bradley Beach, out of the hot city. We didn't have a car—we walked everywhere. We didn't have a phone—all our friends were here. We didn't have a washing machine—we went to the laundromat. We didn't have TV—we talked, read and played games. We didn't always have a refrigerator either, so we emptied the water from the bottom of the icebox in time—or else. And we didn't miss any of these things. But we did have happy, healthy summers for which we were always grateful.

I remember when...my grandparents, Rose and Philip Shill, brought me to Bradley in the mid-'30s. We stayed at Weiss' Villa on Brinley and Ocean Avenue. My grandmother would take the hot baths on the boardwalk during the day and at night they would take me to the pony rides on the beach.

I remember when...Schatzow's Grocery Store was on Newark Avenue. The store was up a steep flight of stairs and on Sunday mornings there was a long wait just to get in.

I remember when...the ice cream parlor was there before Virgil's. There you could get sodas and sundaes and enjoy them at little round tables; a real treat! Then came Jane Logan's on Main Street and Brinley Avenue. This was a popular meeting place to end a perfect evening.

I remember when...it was the summers of '42 and '43 and we were at war. The young boys, both family and friends, had gone across the Atlantic to fight. The rest of us were down in Bradley Beach, enjoying our daily swims in the ocean. We spent every day at the beach. While swimming in the ocean, our group always had to be the farthest ones out. The lifeguards always called us in. We always had the same excuse, for which they couldn't punish us. We were swimming out to meet the boys coming home from war. What a welcome they would have gotten from us...a bunch of teenagers!

Memorabilia from shore restaurants. *Photo by Matt Johnson.*

I remember when…during the war in the '40s there was a bunker built on the beach at Ocean Park Avenue, manned with patrols guarding our precious coast. If I remember correctly, there was some sort of cannon positioned here too.

I remember when…I took the double-decker bus that ran along Ocean Avenue and Ocean Park Avenue into Asbury Park. This was so crowded every Saturday night that it was fun to go for the ride even if you had no destination.

I remember when…we were lucky to have an outside shower. Whether it was a cold shower under the blazing sun or a hot shower under the stars at the end of the day, that was living. When summer ends this is what I miss the most about my summer home.

I remember when…my father David, who was a great fisherman, would come down to the beach after a successful fishing trip and take orders from friends and others "2-4-6" and give them times to come to our house with newspapers to pick up their fish. The times were scattered so everyone would not come over at once. My dad only cleaned the fish for our family. While he was cleaning the fish my mother was already cooking some and by the time the fish were all clean, dinner was ready. What a team they made!

I remember when…my daughters danced in the pavilion. When I was growing up in Bradley Beach we danced right on the boardwalk. There was a jukebox on the boards outside the pool next to Kohr's custard stand and

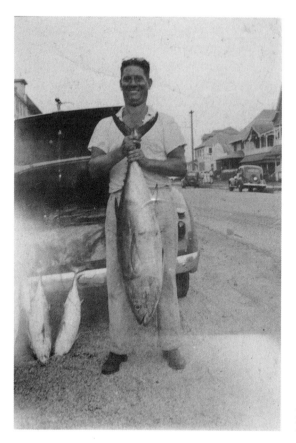

David Gordon, "the Great Fisherman." *Author's collection.*

every evening that is where the youth of Bradley Beach congregated. What a time we had. It is here where we met new friends and old ones from the beach. Many nights, after dancing to the hits of the early '40s, we would walk to Asbury to the Soda Mat.

I remember when…the charm machine was located in the Penny Arcade at LaReine Avenue. For a few pennies my daughters Janet and Bette were sometimes lucky enough to win small charms. Over the years we saved many of these precious memories.

I remember when…my father would write a big, bold "G" on the top of our beach umbrella, so anyone on the boardwalk or crowded beach could spot our family right away!

I remember when…there we were, all spread out on the beach—blankets, chairs, umbrellas. Then along came an unexpected rain shower. We would push everything under the umbrella and head under the boardwalk. There we would wait out the shower, getting our lunch out and joining other families for a picnic under the boards in the rain.

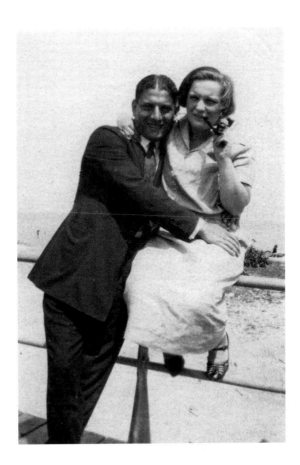

Shirley and David Gordon
having fun on the boardwalk.
Author's collection.

I remember when…in 1937, my parents, Shirley and David Gordon, purchased a bungalow where I spent my summers as a child, a teenager and a young adult. I raised my children here with my husband Lou and now I see my grandchildren enjoying Bradley too!

Oh, for the good old days. May they continue from generation to generation!

Bradley Beach Sand in My Shoes

By Beth Levine Klee

My family has owned a house in Bradley Beach since the turn of the century. We are still there for summers at 102 Newark Avenue (there was once a big green sign on the house that said "Boxer House"), across from the bingo hall, next to the once-luxury apartments. At one time the house was a bakery where the store was downstairs and the family lived upstairs.

Piancone's
Specialty Shoppe.
*Photo by Sam
Ballen.*

My great-great-grandfather divided the house among his children, which has been done for generations now.

As a child and teenager, I spent every summer with my extended family. All of the moms were teachers or housewives, and the dads came down for the weekends. We spent our days on the beach or at the Penny Arcade across the street. (I must admit I recently purchased an old pinball machine from a place in Lakewood, New Jersey. I was quite the pinball wizard as a kid!) Weekends were spent going to the Palace in Asbury Park, watching pro wrestling at Convention Hall or going to the basin crabbing.

I am a teacher as well, and my children, who are young teens and preteens, have also spent their summers at the Boxer House with their extended family. Every Friday we would impatiently await the arrival of my husband, who works in New York City, so we could all go to the pavilion to hear the kids' DJ. Of course we had nice bands when I was a kid.

My father, Harry Levine, was a kosher butcher and my mother used to work as a teen at S & S Market on Newark Avenue, across from Virgil's store. Gosh—the memories are overwhelming! I used to work at Piancone's with "Mom" and "Pop" as a cashier before it was a restaurant.

We are going down the shore to close the house up next weekend—there is no heat—it is still almost the same home as when it was built. I did have some minor reconstruction done to improve the pipes, kitchen, electric, etc. Yes, we have an outdoor shower that my kids love, and a deck on the back and front of the house. We are on the same block as the Carmen Biazzi family and the DiNola family. Carmen died a year or two ago and was a big supporter of the senior citizens in Bradley Beach. In fact one of the nicest things about spending the summers in Bradley Beach now is having my children grow up with the children of the kids I grew up with. I would say that 75 percent of our block is still owned by family that I know and keep in touch with. We all have the "There's Bradley Beach Sand in My Shoes" bumper sticker on our cars.

WONDERFUL MEMORIES

By Pam Cohen Luks

Many a summer I stayed in Bradley at Brenner's boardinghouse. I used to spend a few weeks there each summer, along with my mother, aunt, grandmother and great-grandmother. And the men (dads, uncles, grandfather and great-grandfather) used to come down on weekends.

I recall the fire engine ride on the boardwalk and walking to Asbury Park after purchasing our special treat, a pretzel stick with mustard. I fondly remember the older gentlemen with the "safari" hats who would make sure you had your beach passes. Oh, the boardwalk with the smells of French fries in brown paper bags with salt and ketchup and the aroma of fresh sugar doughnuts! And sounds of the weekly band playing on the boardwalk, with my grandparents and great-grandparents dancing to the tunes, all bring to mind wonderful memories.

THE BEST TIMES

By Amy Weinstein Montuori

My first memory of being at Bradley Beach dates back to 1962, when I was six years old and living with my grandparents at 408 Evergreen Avenue. I remember sitting in an old stroller with chairs piled on top of the canopy and beach bags in my lap. I could barely see or breathe as my mother would

Bette Blum, *right*, with her sister Janet, enjoying rides in Asbury Park. *Author's collection.*

walk the four blocks to Second Avenue beach. Once there, I played with my two friends, Anna Mary and Mary Ann. We would play on the jetties and give names to each of the rock formations. I remember the water always being low tide, with starfish galore, and staying in the water all day.

Another vivid memory was dancing with my grandfather at the pavilion and standing on his feet as he swept me around the square-shaped dance floor. My grandfather was the best dancer in Bradley Beach and had trophies to prove it!

Flash forward ten years to 1972. Then I was sixteen years old, hanging out at Brinley Avenue beach. I met Riva Zweben first by asking her for a match for my cigarette. Riva introduced me to all her friends on the beach. Our days were filled with happy carefree times, such as getting thrown into the water by the boys, giggling and gossiping about boys and actually swimming in the ocean.

Our nights were filled with exciting adventures that taught me about life and growing up in an innocent way. I experienced my first kiss, first boyfriend, first love and first breakup too. Sixteen was a time for exploring and we all did that on and off the beach; under the boardwalk too! I enjoyed playing pinball in Jay's Arcade, hanging out, trying new things and getting to know some great people.

The summer of '72 was the best summer of my life!

HOOKED FOR LIFE

By Richard Schwartz

What is it about fishing, anyway? When does one get hooked on fishing? For me, it was the summer of '69. I grew up on the Jersey Shore with three older brothers. You might think I came from a fishing family, but my dad and my brothers really weren't fishermen. Dad worked very hard and when he got to the beach he just wanted to relax. Cards (hearts) on the beach was his game, and I also remember him not really wanting to get his hands dirty, so fishing was out for him. Besides, how could you deal the cards with scales all over them?

My oldest brother, Elliot, actually spent the summers in the Penny Arcade. He never had a tan growing up and my poor mom had to explain why he was so white while all the other kids and I were always so tan. He was, however, a great pinball player (Doodle Bug—"up and in"). My other brother, Marc, was very good at organizing the younger kids on the beach. He could set up a great game of triangle or running bases. Fishing wasn't his forte. Maybe it was that kid fishing at Fletcher Lake who hooked him in

Richard Schwartz with the "catch of the day," 1976. *Courtesy of Schwartz family collection.*

the arm while casting…it wasn't as bad as the scene in *There's Something about Mary*, but for him it probably was close. No, the guy who taught me how to fish and became my mentor was my brother Steve. Steve is eight years older than me, so when I was about seven he took me with him on those early morning sunrises.

In my eyes, Steve was "the man" at the beach. He learned how to surf early on and to this day was the only one in our family who could master that sport. I remember what a big deal it was to have the surfer's patch sewed onto one's cutoffs. The surfer's swim test was to swim around the jetty; I still think how hard it must have been to do that. Of course this is coming from a guy who almost drowned taking lifesaving in the high school pool. "What do you mean I have to swim down there and swim back with a metal chair on my side?" At any rate, even after my brother took his surfboard in the chin after a wipeout, he kept chasing those waves. But when the surf wasn't up, he learned how to fish. I'm not really sure who taught him, but knowing him he probably taught himself. I actually nicknamed him the "Renaissance Man" because he could do anything (and if he couldn't, he'd convince you that he could). He would argue with such conviction that you had to believe him. Maybe that's why he became a lawyer (and the sharks never bothered him in the water).

Anyway, back to the beginning…my first remembrance of fishing was seeing a sunrise with my brother Steve when I was very small. I was really sick, but he woke me in the dark and asked me if I wanted to go fishing at the beach. Bleary eyed, half asleep, with a running nose, I went to see the sunrise at Third Avenue in Bradley Beach. I don't remember us catching anything, but I know Mom really tore into him for taking me when I was sick. I'll always remember that sunrise and how cold I was just before the sun came up. The sun was fiery reddish orange that day and it really looked like a ball of fire. Isn't it funny the things that stay with you over the years? I learned the basics from my brother but it was my friends (Dickie Bianchi, Steven Farrell, Ricky Feinberg, Tommy Cousins and the rest of the Bradley Beach crew) who really taught me the ropes. My first striped bass was a seven pounder. I caught it while fishing for clams with Ricky—I was about twelve.

I wasn't paying attention and then all of a sudden my rod was bent in half and dancing in the sand spike. I remember an old-timer watching me and shaking his head. Thank goodness the fish had swallowed the hook, the line was strong and the drag wasn't too tight…I must have set that hook thirty times bringing him in. In any other situation I would have pulled the hooked right out of his mouth and lost that fish, but I didn't.

Other great days as a young kid were fluking in the river behind the Headliner off Route 35. We'd ride our bikes and fish off the docks in the back. One time I brought a fluke up who had swallowed my sinker, not the hook but the sinker. That was one stupid fish! Nevertheless, probably the most fun I had as a kid was snapper fishing (baby blue fish). You'd catch them almost every cast and as the summer progressed they'd get bigger and bigger. The key was to fish with really light tackle (very light line and a small metal lure). You could use bait for them but you had to have a wire leader because even snappers have some teeth and they'd cut right through your line.

So why do I share how I got started fishing? Well, you've got the summer to take your son, daughter or any kid fishing. Expose them to a great sport that they can fall in love with and enjoy the rest of their lives. Fishing is really unique in that you can do it almost anytime and anywhere. Most other sports require other participants. Think of any of the team sports (baseball, football, basketball, soccer, etc.). Hey, I love team sports, but you've got to have others to play with. You don't need that for fishing. How 'bout golf? You can play golf by yourself—maybe even show up as a single at the course—but more likely than not you are on their timetable. So maybe that's why fishing is such a great sport. You want to fish? Go right ahead. You don't need a team, you don't need a time, you just go

Richard Schwartz with "the big one that didn't get away." *Courtesy of Richard Schwartz.*

when you want to. Freshwater fishing is okay, but I could never understand the attraction of catching such small fish (at least locally). Although I have discovered freshwater bass fishing, and that is a lot of fun.

No, I believe the thrill for a child is to catch something (anything) that's a little bigger and you do that in the ocean. You don't need a boat to do it either. All summer long you can catch fish right off the beach: fluke, blue fish, striped bass, weak fish, sand sharks, skates and, of course, the New Jersey state fish—the sea robin. Just kidding about sea robins being the state fish, but they are abundant, they're easily hooked and you seem to catch more of those than anything else when fishing off the beach. However, even catching sea robins for a child can be a great experience. Wouldn't you like to see a smile on your son, daughter, niece, nephew or grandchild? The summer will fly by before you know it. So don't put off tomorrow what you can do today—take a kid fishing and don't forget the camera…they'll never be that small again.

BRADLEY BEACH TREATS

By Phyllis Fischman

Bradley Beach has been "down the shore" for all of my life. My great-grandfather built a house at 102 Newark Avenue one hundred years ago and left the house to his son, my grandfather Isaac, who had five children of his own. Needless to say, we are now the next generation!

All of my cousins have spent every summer in Bradley Beach. When we were old enough to work, we all went to work for S & S Market on Newark Avenue. Some of us worked for Morris Shapiro in the deli and some of us worked for his brother, Max Shapiro, in the fruit and vegetable department. On Sunday mornings the place was hopping as everyone in town went to S & S for lox and bagels, and even Matches herring.

After finishing work and before heading up the block to the beach, we all went to Mamie's for a chocolate egg cream. Mamie sold her store to Virgil, and that became the next wonderful ice cream parlor.

The pavilion on the boardwalk at Newark Avenue was the place for meeting kids and dancing, as we all did for years. It was "rock around the clock" for a long time. As the years went by, Mike & Lou's became the next best place for fun and treats in town.

Many wonderful friendships have been made over the years and Bradley has changed considerably. But the olden days were the best and the memories still leave me with a smile on my face.

I'M LOOKING FOR JAY

By Rich Weissman

Richie, Richie, Richie! You know you spent too much time in the local arcade when the owner and his family not only knew your name, but also welcomed you by name every time you walked in, sometimes three and four times a day. Was it the buck or two I spent "banging those pleasure machines," as Bruce wrote, or was it from a '60s attempt at old-fashioned customer service, or what we call today delighting the customer? I think it was deeper. I think it had to do with creating an environment where kids were comfortable, where the rough elements were strongly managed and where parents felt safe in letting their kids spend their hard-earned nickels, dimes and quarters.

I'm looking for Jay. Like Cher, Bruce and Tiger, Jay was known by his first name and was larger than life to a kid who never tired of hanging out in the arcade at LaReine Avenue in Bradley Beach. While the corporate

name hanging over the back door said Bradley Beach Amusements, we all knew it as just "the arcade." Sure, there were others on the boardwalk, and Jay owned them. One was on Newark Avenue and was known as the Newark Avenue Arcade. Later, a small one was opened for a while on Fifth Avenue, but I think that one was nameless and short-lived. When you mentioned the arcade, it was the LaReine Avenue edition. It was the Yankee Stadium of Bradley Beach, and Jay was the Boss. Kindhearted to those who he liked and tough on those who he didn't, he made no secret of who was welcome and who wasn't. He was a good friend, a surrogate parent at times and a great listener. He also knew the boardwalk gossip. Jay was the real deal.

There were pinball machines at Mike & Lou's for a while, and certainly a ton of them in Asbury Park, but they felt, sounded and played differently. When I played those machines, I almost felt I was betraying Jay. He kept his machines clean, in good working order, with a reasonable "tilt" and offered a blend of old and new. He also threw in a free game or two every once in a while. It was always exciting to see what new machines came in at the start of the year and which ones faded away. He kept the classics in good working order, and we all had our favorites, which we played when money was tight and we needed to conserve by winning (sometimes). It seems when we had a pocket full of change, we would take the risks on the new machines, building up the learning curve. But with only a dime or quarter left, it was the old standby that we would embrace. Jay played fair.

More than just an older building that housed pinball machines, Pokerino, skeeball and the occasional charm machine, the arcade was the focal point of the boardwalk, centrally located in the middle of town. It was a place to meet and be seen, to chase and be chased, to laugh and cry. As kids and teens, it was the center of our universe, and personally, it was my home away from home. We always checked in and out through the arcade. If I wasn't on the beach, my parents knew where to find me.

In the summer of 1973, when I was about to go off to college, I really got to know Jay. By then I was one of the older kids, a veteran who started as a tot putting my two pennies in the charm machine or trying to get "points" at skeeball. He saw me grow and I saw the town evolve. We were older and both moving on to other things in life. Some of our conversations were pretty deep, and Jay was more of a friend than anything. We earned each other's trust. We shook hands when I left for college, and I felt sad. I think he did also. We had been together for fifteen years. A lot of quarters, but I never felt I wasted them. We provided value for each other.

A couple of years later, I was walking along Ocean Avenue in Belmar, past an arcade with more neon and noise than I was accustomed to or liked, and I heard the familiar "Richie, Richie, Richie!" It was Jay, working, and perhaps owning, an arcade in a town that seemed to be prospering more than Bradley Beach. We shook hands and chatted about the old days, and commented on the new. I introduced him to my fiancée and we both smiled, remembering the chubby kid with nickels and dimes in his hand.

I'm still looking for Jay. It's been almost thirty years since I saw him last and I want to let him know that I still remember him to this day. Bruce may have gotten "tired of hanging out in them dusty arcades," but not me. I miss it. Thanks, Jay.

The Bradley Beach Experience

By Rheda Sulzman

My husband and I met at Mike & Lou's in 1955. I was sixteen and he was eighteen; and here we are, over forty-eight years later. My family vacationed for two weeks in the summer and we stayed in different boardinghouses. What fun!

I have wonderful memories that only can be shared by those of us who were lucky enough to have the Bradley Beach experience.

Mrs. Radner's Boardinghouse

By Judy Schlosser

> Sitting on the porch swing mostly, happy as a lark
> At Mrs. Radner's boardinghouse, laughing with friends
> Getting up to twirl the hoola hoop every once in a while
> Wish the house was still there so it could take me back.
>
> Nice wraparound porch, on a corner it sat
> Awnings flapping, and the smell of the shore nearby
> Watching the stream of people
> Going by with umbrellas and chairs.
>
> With two dining rooms and a huge kitchen
> A refrigerator and a cabinet for each family

And their own plastic tableclothed spot to sit
With two staircases and three floors, it seemed huge at the time.

But it held up nicely through hurricanes Carol and Donna and more
The sand in the street and the warped boardwalk were left
And the smell of Noxzema and kelp I always felt
Were the memories that linked me to the time and place.

The building burned down in the '70s I was told,
Some hippies partying on the roof or something like that
A regular house stands in its place on Twelfth and A
Anyone else out there remember?

POPSICLES

By Muriel Katchen Reid

The end of summer evokes memories of summers past. Among my favorites were those of the late 1930s and early 1940s when I was growing up in Bradley Beach.

On the beach hundreds of people swam, sunbathed or built sand castles, but some of us chose to be in the shadows under the boardwalk. No, it was not for sex. It was for Popsicle stick games, an activity of pre- and early teens of those times and in that place. The object of the game was to toss a Popsicle stick cleanly into a two- or three-inch trench in the sand located about five feet from the toss line. The trench was dug by an enterprising youngster who charged one Popsicle stick as game admission and paid out two or more sticks to successful tossers. The more difficult tosses, created by varied anglings of the trench, warranted the higher returns.

Getting "seed money" for a game start-up meant combing the beach for discarded Popsicle sticks, which was more productive then, when environmental concerns were nil and trash was carelessly discarded. It could also mean getting one's parents to subsidize the purchase of Popsicles. Fortunately, my parents saw ice cream as a health food, so I had no problem. Another way to accumulate seed money was by becoming skillful at winning in other peoples' games. It required about fifty sticks to start a game and anybody could become a proprietor. There were no building codes or supervisors. The process was very orderly. I now marvel at the ability of children to maintain the system without adult supervision.

The games could be a humbling experience in dealing with poor design, i.e., making the game so easy that one quickly went out of business. I

experienced that several times. There was a face-saving system for dealing with business failure. One went up to the boardwalk, shouted "Scramble" and tossed the remaining sticks to the beach for others to pick up, or perhaps to fight over. Although the game owners were of both sexes, girls did predominate. I wonder if many of the girls went on to become business owners using the skills learned in establishing credibility, meeting competition and enticing customers.

At the end of the summer, in a good season I accumulated several boxes of sticks. Over the winter I periodically counted and recounted the profits, savoring the concrete evidence of my "commercial" success. I also thought about new game designs for the next season, using longer and shorter distances from the base, deeper trenches and different trench angles. It could occupy hours of dreaming and discussions with friends, who were, however, competitors, so one could not reveal too much. If only we had known then about non-disclosure agreements.

The end of my freshman year of high school was the end of the journey for the Popsicle stick games. Boys came on my horizon and the daydreaming shifted. The games appeared childish, but I maintained a soft spot for them and sometimes would enter the arena and offer the advice of an elder statesperson. When my proffered advice was rejected with, "How would you know?" I knew it was time to retire. That was the summer I became a really good swimmer.

Every time I've eaten a Popsicle since then, admittedly not many, my instinct is to save the stick. Maybe, the perfect game is still to be invented and perhaps a much elder statesperson could have a role. Then I remind myself that in Bradley Beach the boardwalk has been reconstructed so that there is no "under the boardwalk." It's over!

Fond Memories

By Barbara Brooks Kimmel

My grandparents, Nate and Sarah Peck, bought a house on Fourth Avenue in the early 1960s and moved there from Irvington after spending several summers in a rooming house. They also built a garage apartment behind the house, where my aunt and uncle lived.

Some of my happiest memories as a young child in Bradley were going to Vic's on Saturday with an empty pot and filling it with spaghetti for a big family feast; the weekend Farmers Market in Neptune; meeting all the Gindis who would rent houses near my grandparents in the summer; walks on the beach in the winter and "accidentally" falling into the water; going

Charms from the Penny Arcade. *Author's collection, photo by Matt Johnson.*

to the bakery on Sunday mornings for cinnamon bread; Evelyn's; the sound of the train; the outdoor shower.

As I grew older, my parents started leaving me with my grandparents for the month of August so they could travel (without my sister and me). I spent three summers in Bradley from 1970 to 1973. By that time, my grandfather was working as a beach checker near the Fourth Avenue pavilion and my grandma would spend the days with the "ladies" on the Fourth Avenue beach. On rainy days, we would go to the library or spend lots of good times at the Reichs' house on Second Avenue.

Other fond memories include playing stoop ball; hanging on the beach with my friends—Jill Reich, the Grills (Billy and his sister Pola), the Norths (Sandy and Cyndi) and Steve Geller; all the Johnson's Baby Oil, lemon juice

and Sun In; dating a lifeguard when I was sixteen. My grandmother would not let me go to the lifeguard bash at the end of the summer "because nice girls didn't do that." It was probably the best decision she ever made; lighting punks under the boardwalk; the Penny Arcade—I still have my charm collection; soft ice cream; walks to Asbury Park; the concerts at the band shell (boring); deciding what to have for dinner. My grandmother cooked three dishes: roast chicken, Chinese (spaghetti with soy sauce) and Italian (spaghetti with ketchup); walking down to Fourth Avenue beach to say "hi" to Grandpa and get some warm fruit from Grandma; the summer when Bruce Springsteen rented a house with a group of friends across from my grandparents. Of course, he was just getting started back then, so walking to the beach with him was no big deal. (He wore a black Speedo.); sitting on the front porch with Grandma after dinner and listening to stories about the "old country."

My grandmother passed away in 1974, right after I graduated from high school, and my grandfather moved to California to live with his sister. The house was sold. I loved my summers in Bradley. They were some of the happiest times in my life. Every year, I make at least one trip back to Fourth Avenue to see the old house and reminisce with my kids about growing up there.

Truly a Bradley Beach Baby

By Marc Alan Schwartz

I am truly a Bradley Beach baby. My mom and dad bought a four-room bungalow on Madison Avenue the year I was born, 1957. We were living in Newark at the time and later moved to Maplewood when I was in the first grade. I remember my early years at the shore as much as I remember my teen years. My brothers and I used to go to a day camp in Ocean Grove for half a day and play knock hockey, softball and do arts and crafts projects. We also would go fishing at Fletcher Lake for sunnies and sometimes catch the elusive golden carp.

It was at the lake when I was six years old that I got hooked in the arm by my older brother Steven and had to go to the emergency room at Fitkin Hospital (now Jersey Shore Medical Center). It was one of several visits to the hospital that my mom had to make for one of my brothers or me in the summer. I got a taste of my first tetanus shot at the shore after stepping on a rusty nail. All I can remember is the fear of getting lockjaw if I didn't get the dreaded shot (in the butt of course; how embarrassing in front of my mom and that young nurse!).

The day camp in Ocean Grove also gave me an opportunity to meet one of my best shore friends, Jay Jenkins, who lived in a big house on the lake in Ocean Grove. Jay and his brothers were into the pop music scene and played live music in their living room. I couldn't play an instrument or the drums like Jay, so they gave me the mike to belt out our rendition of "I Can't Get No Satisfaction" by the Stones. Jay and I played a lot of street football with his brothers and motored around the lake in his boat. I learned a lot of shore activities from Jay and I will always cherish those experiences and his friendship.

The most poignant memory of these very early years at the shore was breathing in the fresh saltwater air when we first got down to the beach. The weather was still a little chilly and of course the water was ice cold. It would be a few weeks before the water warmed up, so we spent a lot of time in the Penny Arcade and at Virgil's (on Newark Avenue) banging away at the pinball machines he had in the back room. My brother Elliot was an expert pinball player and Virgil named him "Wild Bill Elliot." This was when a slice of pizza and a soda cost us fifty cents and our version of the boom box was a transistor radio tuned to 77 WABC and a new disc jockey calling himself Cousin Brucie.

We used to arrive at the shore for Memorial Day weekend and start the cleanup and painting projects for the summer. My dad liked to have the wrought-iron rails painted white and I seemed to get this tedious job each year. It seemed to take forever, but eventually I finished and it gave me a good sense of accomplishment, which I still get today when I complete a home improvement project.

When I was in college and down for the summer in June, I painted the siding on the house and all of the woodwork. I took a lot of pride in this and I think my dad appreciated my initiative in getting the old gray asbestos siding painted. Of course we kept the same gray color, which over all of the years seemed to be the best color for the old bungalow. My dad used to say the bungalow was put together with spit and glue. For an investment of only $6,000 in 1957, it served our family well over the years as the summer getaway.

When I was about fourteen and "coming of teen age," my older brothers encouraged me to make the move from Park Place beach (where my parents and their temple friends camped out) to Brinley Avenue. Brinley was the teen scene and if you weren't part of it, it would soon lure you in. This is where I met my summer friends and eventually my summer girlfriends.

When we got hungry we could always return to my parents' beach for the obligatory tuna and tomato on a roll from the S & S Market. All year back in Maplewood, we would rarely have a roll for breakfast, but at the shore we would always have fresh seeded hard rolls from the S & S Market around the corner on Newark Avenue. Back to the beach scene: I remember the waves

were always better at Park Place. Brinley was for mingling, but not great for body surfing. I also remember the currents and tides were particularly strong along the jetty at Park Place beach.

One time when I was around ten, I was swimming with a group near the jetty and the guards started whistling us over to the ropes. I started swimming against the current but I was being pulled closer and closer to the jetty. All of a sudden, I was being picked up and thrown in the air by a lifeguard who proceeded to yell at us for not obeying his whistle. I was exhausted from swimming against the current and I would have liked to thank him for saving me, but after he yelled I was terrified so I got out of the water and made my way back home. I always had a deep respect for the tides and undertow after that experience. Years later, there would be multiple drownings along the shore due to riptides. I can relate in a personal way to the feeling of being trapped in a current and not being able to get out of it.

On Park Place beach, we also liked to play a game called "buzz," which was like dodge ball but you would have to cross the line and tag someone without getting tackled within your opponent's side of the line. This game was usually followed by Dick Fosbury (remember the '68 Olympics?) flops over the crashing waves or tossing an innocent girl by the legs and arms into the surf. It was amazing that without reading a single book all summer (other than an Archie comic book) we could occupy a whole day at the beach and do it again the next day and the next all summer long.

DAYS AND NIGHTS IN BRADLEY BEACH

By Bette Blum, as told by Jerry Bieler

Jerry Bieler went down to Bradley Beach from 1946 until about 1954. He stayed with his family at his Aunt Minnie and Uncle Mac Sussman's home, which was once the Lake Shore Hotel near Fletcher Lake and Ocean Avenue. Jerry and his cousin Marty Sussman would go to the beach and spend a lot of time on Brinley Avenue beach playing gin under the boardwalk, fishing off the rocks, playing football with ten to twelve guys on a team and enjoying the surf, sun and sight of the girls who surrounded them each day.

At night he and his friends would go to the boardwalk in Bradley, meet friends at the grand Essex and Sussex Hotels in Spring Lake, hang out at Mike & Lou's, walk into Asbury Park, go on the famous Ferris wheel, dance by the pool of the Berkeley Carteret and even get a glimpse of Zero Mostel at the West End Casino.

As a teen, Jerry worked at several jobs with his cousin Marty. They both worked for Syd Goldstein at Syd's famous hot dog stand on Ocean Avenue in the LaReine Hotel. Syd's hot dogs were boiled in a pot near an open window in the front of the store. Syd would stand there with a fork, jab the hot dog and throw it out of the hot pot into the bun, use the same fork, grab some mustard, throw it on, use the same fork, grab some relish, use the same fork, take some sauerkraut, throw it on…all for thirty-five cents!

Jerry and Marty also worked in Asbury Park at Pappy's in the LaReine Hotel and in the Berkeley Carteret as room service waiters. Years later, Jerry's cousin Marty took over Walter Reade's restaurant near the Third Avenue Pavilion. He called it Martin's Bamboo Room, which was soon nicknamed "the Baboon." They had good food there and made huge ice cream sundaes; kids used to line up night after night for this fabulous treat.

Jerry was a typical teenager in Bradley, but he shared these stories from when he and his friends were the "Bad Boys of Summer."

One day after the season was over and the ropes were gone from the ocean, Jerry assumed he could swim wherever he wanted to. He was a very strong swimmer and knew how to navigate the ocean waves.

He was out there swimming and before he knew it Mac, the head of the lifeguards at the time, motioned him to come in. He and Mac never got along and, since it was after Labor Day, Jerry continued to enjoy the surf. Mac kept blowing his lifeguard whistle and Jerry was so annoyed he finally swam to shore.

When he reached the shore he was angry and peeved and said, "Mac, where the hell are you supposed to swim?" Mac, with all of his lifeguard authority and presence, answered, "Are you being a wise guy? You are under ARREST!"

Mac threw an arm lock on Jerry, so Jerry clipped him. Arrest? Jerry was just enjoying the last swim of the summer and fought back. Before he knew it he had six lifeguards all over him. They just jumped on him and called the Bradley Beach Police. Jerry was arrested and sent right to the Bradley Beach pokey! Good old Syd bailed him out. Jerry was soon tagged "the Jailbird!"

It wasn't over then. He soon met an interesting gal and asked if she would go out with him. She said, "No way can I go out with you, my mother told me you are a jailbird!"

All that for swimming on the wrong side of the rocks after Labor Day!

Jerry and his friends—Jerry "Jason J. Penguin" Skolnick, Eddie Bank and several others—would enjoy a night of watermelon filled with any vodka

they could find in and around Bradley Beach. When the boys got rowdy they would take the truck from S & S Market on Newark Avenue, where some of them worked, and head west on Route 35 to the farms.

There they would run through the cornfields and fill up the truck with as much fresh corn as they could pick and head back toward Bradley Beach. For some reason they found lots of fun in dumping mounds of corn in front of the houses of the police chief and the mayor of Bradley Beach at that time. They never knew if the mayor found it funny, cooked the corn, sold it or knew how it reached his doorstep.

This corny, teenage shenanigan should be every mayor's biggest problem!

Jerry and his friends were mostly Jewish boys from Newark and parts of New York. Every so often, the (Jewish) Syrian boys who came from Brooklyn and lived in the southern and more upscale end of Bradley Beach, near Second Avenue, would come to the beach with bandanas on their heads to claim the territory of the Brinley Avenue beach for themselves and their friends.

Unfortunately, all the boys would get into fights every time. Time after time, the boys from Newark continued to win and the Syrian boys went back to Second Avenue, where they dominated the beach and held court at the "Syrian Beach" for years.

Whose Bradley Beach is it anyway?

ONE MEMORABLE SUMMER

By Maxine Cohen Glazer

It was the summer of 1963. My friends and I were entering our senior year of high school that following fall. One of my dearest friends of all time is Judy. We were both sixteen years old that summer and I have no idea why our parents allowed us to go to Bradley Beach by ourselves! I guess it was a time of trust and since we were unable to drive yet, we'd find an older friend to hitch a ride with to the shore.

We stayed in a rooming house at 305 Fifth Avenue...wow, I even remembered this address! Every week we would pack like we were going away for a month. Some major essentials, at that time, besides clothes, swimsuits and towels, were transistor radios; bobby pins (for our French twists); mohair sweaters for the cool evenings; baby oil and iodine for our tans; sunscreens (not for protection from the sun, but for frying our faces!); Pond's cold cream; Ambush and Windsong colognes; and plenty of sandwiches for the beach.

After broiling on the beach for at least seven hours, we'd take our outdoor, backyard shower, which was usually cold! We would get all dressed, tease our hair to the max, spray it and out the door we went. We'd walk to Ocean Avenue and parade back and forth, between Mike & Lou's and Syd's, two very famous hot dog and fries establishments. And why would we be parading back and forth? It was to look for the guys we had met that day on the beach!

Nostalgic memories were the bingo hall, Master's Bakery on Main Street, fresh produce from the market stands, no supermarkets, soda and Good Humor ice cream and ices sold on the beach. I also remember the famous hangout streets, McCabe and Brinley.

It was a happy time, packed with memories my children never got to witness. After I married and had children, Second Avenue became my hot spot. No steps to schlep all the sand toys, ice chest, thermos, carriage, playpen, towels, lotions, sunscreen number 39!

Life goes on at Bradley Beach.

The Eric House and Beyond

By Bette Blum, as told by Ida Tepper Zagnit
Ida loved Bradley Beach. She lived in Bradley Beach since the 1950s. She was the owner of the Eric House, named for her youngest son, which stood around the corner from Syd's. The Eric House was a rooming house with an additional eight bungalows on the first block of Brinley Avenue from 106 to 114. The Eric House also had a forty- by sixty-foot swimming pool, which was one of very few that existed in Bradley Beach.

Ida would only rent to families who had children, as when one set of kids was noisy nobody would complain as they knew theirs may be noisy next!

Ida told of fabulous times in Bradley with friends, neighbors and family. One night she recalled playing Kaluki, canasta and mah-jongg with "the girls" and all of a sudden Sergeant Young came to her house. The police had received a call that there was a disturbance in the area and it ended up being Ida and her friends carrying on and having fun. She admitted that she and her friends probably made even more noise laughing about the incident when the police left, as they were the cause of all the police activity!

The good old days for Ida in Bradley Beach were filled with women who dressed up in mink stoles, walks on the boardwalk, the grand LaReine Hotel, parades, pageants, Penny Arcades, terrific concessions and kiddie

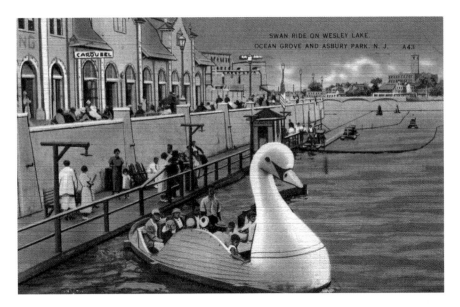

Swan Ride on Wesley Lake, Ocean Grove and Asbury Park. *Author's collection.*

rides. Ida also experienced wonderful times in Asbury Park with Minsky's burlesque, rides, amusements, treats and casinos.

Living in Bradley Beach made Ida feel as if she had both the country and shore living all in one. With the prices of housing going way up in Bradley, Ida had said, "I could get so much for my house on Second Avenue, but who would want to leave this place!"

"It is a wonderful town," she told me, "the most wonderful town in the world!"

Learning to Drive in Bradley Beach

By Marc Alan Schwartz

One of the great benefits of having a birthday during the summer was being able to celebrate at the shore. I was born on July 6, so the fireworks on the Fourth came at the same time as my birthday. This was always a special week in the Schwartz house for the whole family. I remember that every town had their fireworks on different nights, so we were assured of a show on the boardwalk every night of my birthday week. This was also the time of the summer when everything was falling into place. The cool days of June gave way to the summer heat wave in July and the beaches were filling up early with vacationers and day-trippers.

I turned seventeen in 1974 and recall taking my driving lessons from my dad and older brother Elliot that summer. The car I learned to drive was my dad's Buick Electra 225. This was a particularly long and wide car and it was a real challenge to parallel park. The parallel maneuver was a key to the driving test, but it actually was critical to parking in Bradley at any time. You would need to size up a space and back it in just about anywhere in town. The sloped (turtle back) roads also made it more difficult as a new driver. At the driving test in Eatontown, I messed up on my first attempt to parallel park, but the DMV guy let me do it again. I guess he sympathized with the large car that I had. Backing out on the angled parking spaces along Ocean Avenue was also no Sunday drive, as the length of the car and the blind spots made it difficult to see the oncoming traffic until you were well out into the street.

The streets in Bradley seemed so narrow with cars parked on both sides. With every stop sign it was a major victory to have made it through the intersection without having an incident with a speeding car coming the other way. My friend Skipp Silverman and I liked to race the S-curves along Lake Avenue from Main Street to the beach. Skipp had his driver's license a year before me, so he had the wheels that we all longed for to get around. Skipp, Alan Tilsen and some others used to frequent the clubs in Asbury or Belmar and end up at Vic's Pizza for some late night beers and pizza. It was a good time had by all.

I remember one night after I had just got my license; I was driving a whole group of us to the Inkwell in West End. The Inkwell was one of the first coffee houses, decades before Starbucks and the others were conceived. I remember my older brother Steven introduced me to the Inkwell when he used to go with his group of friends. This was my first time driving with so many distracting people in the car. I almost plowed into a parked car making a turn on Brinley Avenue. I swear I grazed the old Electra (and that my dad would surely have my head that night). The drive to West End at the time was along Ocean Avenue and it gave all of us a view of the big shore houses in Deal and Elberon as well as the night action in Asbury Park.

The freedom and empowerment of having a car and being able to go someplace farther than Bradley was a great feeling. When I returned to school in the fall, I bought my first car, a Chevy Chevelle, and drove that car right through college. It was a lot smaller and easier to park than the Electra, but I will always remember that summer of '74 for the driving and the other experiences of coming of age at the shore.

Vic's Restaurant. *Photo by Sam Ballen.*

LOTS OF GOOD MEMORIES

By Barry Goldberg

Wonderful memories
Since the 1940s in Bradley Beach
Watching horse-drawn carts on the beach
Grandfather by my side
Beach parties on Newark Avenue
Better get your bonfire permit
Roberta's Grandpa Zall's produce truck
Fishing carts and fish markets
Rowboats in Fletcher Lake
Ride under the bridge
Hotels in town
Cohen's, the Alpine, New Brinley, LaReine and Bradley
Treats all over town
Mike & Lou's and the ice cream parlor on Fifth Avenue
Constant walks into Asbury Park
Arcades, rides, amusements and always a good time
Madison Avenue
My house is still my home in Bradley Beach

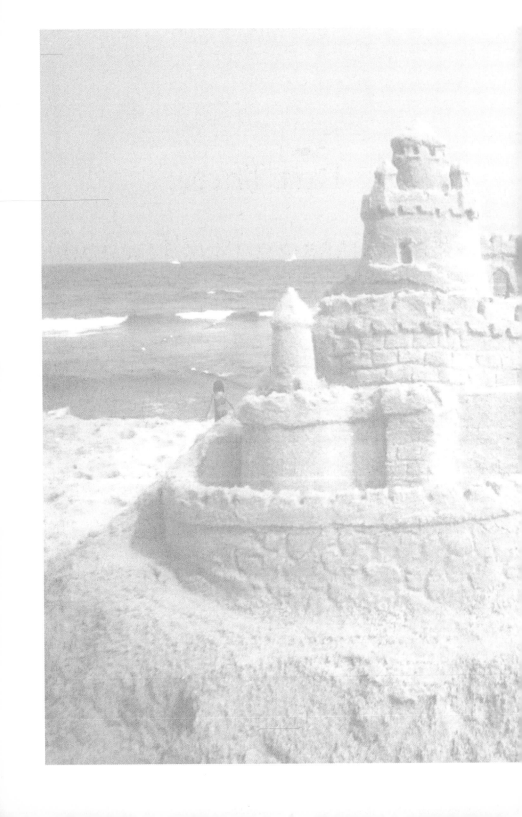

Part Three:

Sea Glass and Driftwood

BRADLEY BEACH THEN AND NOW

By Gladys Gordon Blum

When I first started going to Bradley Beach as a child in 1937, there were many houses and bungalows that families rented for the summer, returning year after year. There were large hotels and smaller ones such as Lin's, Weiss Villa, the Mayflower, the Brentwood and numerous rooming houses all throughout Bradley.

After a period of time the "renters" purchased many of the summer homes and the smaller hotels became rooming houses. The vacationers who stayed in rooming houses usually had a Fourth of July party and a season-end beach party. They were always quite a success and an inducement to return the following year.

The beaches were great in Bradley Beach. Many times we would have to move our chairs and blankets back again and again as the tide came in. Folks came to Bradley to walk the boards, take a hot bath, sit on the benches and watch the waves break and the tide roll in. Walking the boards, one could always look down to the beach and find family and friends.

Over the years, many of the homes were winterized, the hotels and rooming houses became condos and apartments and the beaches were all enlarged. The "boardwalk," as we still know it, became a stone walkway. Gone are the days of splinters. Today beautiful flowers adorn the boardwalk. There are only a few rooming houses and no hotels left. The ice cream parlors (Sally's, Jane Logan's, Phil's) became bakeries and restaurants. The bowling alley

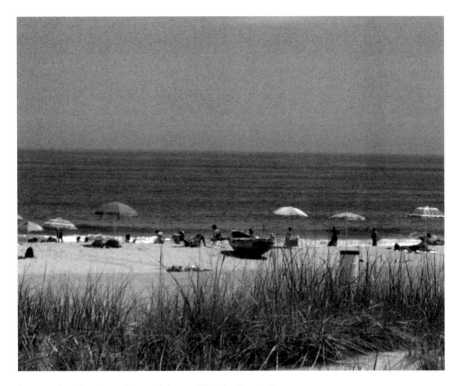

Bradley Beach today with sand dunes. *Photo by Sam Ballen.*

became a bingo hall and we have a wonderful playground where the kiddie rides once stood. The large pavilions and our great swimming pool with its balcony are gone, along with the fun arcades. Gone too are the buses along Ocean Avenue and Ocean Park Avenue.

Today it is a long walk from the boards to the ocean and if you are just strolling on the boards you cannot see the waves rolling in or breaking against the coast. If you come to Bradley Beach today you would see all of these changes and be able to enjoy the many gourmet restaurants Bradley is now known for. Some say change is good and some like things the way they were.

I guess I'm lucky; I've seen the best of both worlds.

Bradley Beach History

By Shirley Ayres (Official Bradley Beach Borough Historian)
When I was asked to send an article to Bette for inclusion in this book of memories of Bradley Beach, I gave a lot of thought to the Bradley Beach of

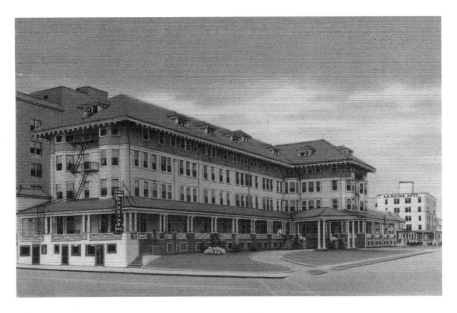

LaReine Hotel. *Courtesy of Shirley Ayres.*

the 1970s. That is when Bette and her buds used to hang out at the Brinley Avenue beach during the summer. That particular group of people has tons of great personal memories to fill hundreds of pages in any book, so I knew I could never compete with the "gang." Nor did I want to. My memories are of different times and places. That is when I decided to give a little history lesson on one of the most wonderful, most beautiful and famous places at the beach: the LaReine Hotel. The hotel was still functioning when Bette and her buds were doing their summer thing. They visited the shops at the hotel and ate at the boardwalk stands across from the hotel. They remembered the LaReine.

The LaReine Hotel was built at the corner of LaReine and Ocean Avenues in 1900, when the beachfront was practically deserted and only houses were facing the Atlantic Ocean. It was a bold risk, which paid off handsomely in a few short years. More and more summer visitors were coming to Bradley Beach by train and, to accommodate the day-trippers, more and more hotels and rooming houses were being built. Tourism was a big thing, thanks mostly to the trains that ran directly from New York and North Jersey to the shore. The LaReine Hotel had several horse-drawn carriages and, later, motorcars to meet guests at the station. The hotel had five hundred guest rooms and each one had an ocean view. There were two huge dining rooms and a host of employees to attend to every whim or problem presented by the guests.

Around 1915, the hotel owners decided that an outdoor saltwater pool was needed and so one was installed. The veranda was extended to shield the pool from public view and the hotel staff was expanded to include lifeguards and pool maintenance. About this time, the hotel hired a professional boxer to give boxing lessons to young boys, a professional swim instructor and a professional physical fitness trainer to lead guests in daily exercises. Business was booming and the guests were getting more than their money's worth. There was so much repeat business; vacationers hoping to stay at the hotel had to make reservations months in advance.

Every year during the 1920s, the hotel sponsored summer-long Mardi Gras celebrations. During the Memorial Day weekend, a queen of the event was chosen from among the many young women visitors who entered the contest. Each weekend after that, a member of the queen's court was chosen until she had eight princesses. The hotel held beach parties, dances and dinner parties with the queen and her court in attendance. Finally, on Labor Day weekend, after a flurry of social activities, there was a grand parade on Ocean Avenue, featuring marching bands and colorful floats. Prizes were awarded, by the queen of course, in several categories to the parade participants. That night, there was a dinner dance at the hotel, followed by fireworks on the beach across from the hotel. The next day was Labor Day and most of the visitors went home with wonderful memories of the Bradley Beach Mardi Gras.

In September 1928, the LaReine Hotel hosted the National Chess Tournaments. The best chess players from all over the United States were invited to attend the matches, which lasted about one week. Mayor Frank Borden of Bradley Beach welcomed the attendees with a banquet in the hotel. Members of the *New York Times* and the *Brooklyn Herald* were on hand to record the matches and interview celebrities, of which there were many. Plans were made to host the International Chess Tournaments in June of 1929. The hotel owner, Vincent Spark, decided to build a brand new hotel adjoining the LaReine to house all the expected visitors and chess champions from all over the world.

The new Bradley Hotel was finished in time for the chess matches in June 1929. This time, not only the *New York Times* and the *Brooklyn Herald* were there but New York radio stations also sent mobile equipment to record the matches and hold interviews with the champions. Incidentally, the *New York Times* and the *Brooklyn Herald* kept summer offices in Asbury Park. They were always on hand for local happenings. Mayor Borden had his picture taken with the world's most famous chess champions. There were banquets every night, hosted by the newspapers, the town of Bradley Beach and the New York Chess Club. Thousands of visitors crowded the sidewalk outside the hotels to get glimpses of the chess masters. It was a wonderful time.

October 1929 brought the stock market crash and a halt to the Mardi Gras parades. Summer 1930 was one of the worst financial times for the entire Jersey Shore. The few visitors who were not affected by the Depression were not traveling as frequently as they had in the past. The LaReine-Bradley Hotel complex suffered as a result of the nation's economic woes. In the late 1930s, things were beginning to look up again for the hotel, until World War II became a reality.

The hotel never again realized the prosperous years that prevailed in the first thirty years of its existence. Post–World War II, the LaReine-Bradley Hotels were trying to get back to their glory days, but it would never be the same as when every hotel room was occupied all summer long. Finally, on April 1, 1974, an early morning fire, whipped by strong easterly winds, consumed both hotels, leaving nothing but memories.

SWIMMING THE JETTIES

By Robert E. Drury

The ten years I lived in Bradley Beach (1979–89) were the happiest years of my life. My favorite memory was waiting until the lifeguards left for the day and swimming out past the jetty at McCabe Avenue and swimming to the Shark River Inlet jetty. I'd swim to the Columns bar for a double Bushnell's on the rocks and then swim back to McCabe Avenue.

I certainly was in great shape then.

SEPTEMBER RESCUE AT SEA

By Muriel Katchen Reid

I was a local. Born in Newark, I moved to the seashore when I was eight and went to Bradley Beach Grammar School and Asbury Park High School. My father operated a pharmacy in Neptune. I loved growing up at the beach.

I had two lives—my winter life and my summer life. I kept them apart, except in September, when my summer friends still came for day visits to the beach. September is warm and beautiful at the seashore and the ocean is very warm, very pretty and very treacherous. The riptides come on very quickly and can wreak havoc, as they did with me and my two summer friends. It was a warm day and we, at about sixteen years of age, went to the beach and into the water.

It was low tide. The beach had a few people but no lifeguards, since it was past Labor Day. The water was below waist level as we entered and

stood there talking. We talked and talked and then one of us looked toward the beach and saw that we were way out and realized that we were treading water. We said, "Time to go in," and we started to swim and found we couldn't. A riptide not only prevented us from swimming in but began to pull us farther out. This was before I learned how to swim with the riptide.

It was frightening, and then terrifying, as we struggled to swim toward shore, each of us waving and screaming for help. And, miracle of miracles, a lifeguard who happened to be walking on the boardwalk saw us, ran down onto the beach and prepared to rescue us. And, another miracle of miracles, there was still lifesaving equipment, including ropes, left on the beach. A third miracle of miracles, our savior was a one-armed lifeguard. He tied a rope around his waist, enlisted the help of someone on the beach and swam with his one arm toward us. He reached me first and while the others held each other up, he pulled me into shore with my face under water half the time, but I did not dare complain. He then went for the second friend, who later told me that she kept arguing with him about having her face in the water and he threatened to leave her. The third person managed to get in without help.

It was a landmark experience. I had had one near-drowning experience before, but that was quickly solved. This one was a lot closer to not being solved. I learned never to swim on a non-lifeguarded beach and have held to that all my life at the seashore. I own a house in Bradley Beach, and still go there during summers. When lifeguards leave the beach I don't go in the water. I have also learned about riptides. But, however frightening the experience was, it left me with the feeling that Bradley Beach was a safe place and I would continue to be taken care of—rescued, if necessary. And September water is still so beautiful.

Note: Bradley Beach now has signs at each entrance to the beach with riptide cautions and swimming instructions.

FISH STORY

By Sandy Kaston

Every fisherman has a fish story. My Uncle Simon was a fisherman. He loved to go fluking. He had a small boat with an outboard motor that he would trailer down to Shark River. He usually took along guys who he knew would get seasick—that way once they started "chumming" he could snag the sandwiches that they brought to eat.

I will always remember my uncle bringing huge stringers of giant doormat fluke into the backyard at my grandfather's house on Ocean Park

Scott's Bait & Tackle. *Photo by Sam Ballen.*

Avenue in Bradley Beach. He did such a horrible job filleting the fish that when he served it there were always bones to be found. Needless to say, I did not care for fresh fish when I was growing up down the shore.

Though my uncle took me for a few boat rides, I never did get the opportunity to fish with him before he passed away. However, nowadays, when I'm fishing on my own boat and things are going slow, I'll look up to the heavens and ask Uncle Simon for a little help. He always comes through. I am proud to say that I am almost never skunked on a fishing trip. Someone onboard will always catch something. I guess Uncle Simon still keeps an eye out for me.

THE JUNIOR LIFEGUARD

By Bruce Kreeger

I guess that from the earliest of ages I remember going to the beach with my mother, grandmother and, on occasion, my father.

According to my mother, Harriet, I was weaned on seaweed and most likely developed my love of sushi and seafood right on the beach at Ocean

Park Avenue in Bradley Beach. I can remember being around the age of five or six in the early 1960s and having my first bite of sand crab. I remember my grandmother almost getting ill as they walked me to the lifeguard stand, and asking those men sitting way up there, "Are these things poisonous?" "Of course not," came the response, "but maybe you should let the little guy know not to put things in his mouth."

I was hooked; from that moment on, I just could not get enough of those guys—the lifeguards.

By the time I was seven or eight years old I joined the ranks of the "junior lifeguard." At the time, this was an unofficial group of boys and girls that would do all sorts of things just to be around the lifeguards. Every morning, we would get to the beach before them, usually by 7:30 or 8:00 a.m. Before they got to their assigned beaches, the lifeguards needed to pick up all sorts of gear from one of three lifeguard locker rooms that were on the boardwalk. One was at Newark Avenue, one between McCabe and Brinley and the third was between Second and Third Avenues.

"Ours" was at the pool between McCabe and Brinley. So there we would meet, early every day, all summer long, the "junior lifeguards." Then, after receiving the okay from one of the senior lifeguards, we would carry the first aid kit (a big wooden box loaded with neat stuff), at least one torpedo, a spool of rope (line they called it), the umbrella, a paddle board and anything else that the guards chose to pile on us.

Then we walked over the boardwalk, down the stairs and onto the beach. We walked about one hundred yards to where the lifeguard bench would be set up for the day, dropped "our" stuff on the sand and waited for the guards to drag the bench to the shoreline; it was much too heavy for us and took at least two guards to drag it. While they dragged it down, one of us would scurry over to the lifeguard boat and grab an oar. This oar was used to keep the bench from falling backward, and it was also used to "dig in" the bench. We would dig the front two legs of the bench into the sand to get it set in a sturdy fashion. Once we were done setting the bench and putting all of the equipment where it belonged, we all went to turn over the lifeguard boat and drag it closer to the ocean; not too close, but just close enough.

Occasionally, particularly at a low tide during the week when the ocean was not too rough, we could get the lifeguards to take us out in the boat with them as they practiced rowing north and south just off the jetties.

I remember thinking, "Why would anyone want any other life than that of a lifeguard?"

Every year the Bradley Beach Beach Patrol sponsored a lifeguard tournament that put the guards from one beach against the guards from another beach. This was usually done on a Wednesday or Thursday in the

late afternoon or early evening. All junior lifeguards had to attend; it was mandatory! We didn't compete. We just watched and helped get equipment there. In the later years, the tournament went on to bring out competing towns. Bradley Beach, Avon, Belmar, Ocean Grove, Asbury Park all sent their best guards and we always had the best junior lifeguards!

By the time I was ten or eleven, I was ready to take on anything. I remember saying to Dennis, the captain on Ocean Park Avenue and later the chief lifeguard, that when I grew up, I was going to be a lifeguard too. He always encouraged me!

The lifeguards used to play pranks on us. Once, I remember being told by Dennis to go to Brinley Avenue for one hundred feet of shore line. So as a good junior lifeguard, I ran (yes I did) all the way to Brinley. I walked up to the lifeguard bench and told them that I was from Ocean Park Avenue and that Dennis needed one hundred feet of shore line. They told me that they were out of shore line and suggested that I run down to Fifth Avenue, where they surely had enough shore line for Dennis. So I ran from Brinley to Fifth Avenue. Of course, they had none and they sent me to Second Avenue for some. At Second Avenue I was told that the only place that had enough shore line to spare was on Newark Avenue and that if Dennis really needed it, I should run there on the boardwalk to get there quicker. So I ran all the way from Second Avenue to Newark Avenue, which was about one mile. I ran barefoot over that boardwalk and down the stairs over to the lifeguard bench. I belted out my request for one hundred feet of shore line for Ocean Park Avenue and was very quickly told that Ocean Park Avenue already had more than one hundred feet of shoreline and that they didn't need anymore! Wow—was I dumb. The next day, Dennis gave me my lifeguard patch.

Was I ever proud. That patch was sewn onto my swimming trunks that night by my mom. I wore those trunks all day long, every day for the entire summer. Mom would wash them over and over.

I never did become a lifeguard. I obtained my Red Cross certification, swam my mile in the ocean many times and was even offered a position. I became an EMT and did a short stint as a police officer, but never did become a lifeguard. But I was one of the best junior lifeguards that Bradley Beach ever had, and I am darn proud of it!

THE LOCAL

By Bryan Feinberg

I grew up in Bradley Beach. Actually, the house I grew up in on Park Place was transformed from a grocery store in the 1950s.

Bungalow in the snow. *Author's collection.*

I was one of the kids who stayed on for the winters. I totally looked forward to Memorial Day to see my summer friends. Unlike my brothers and many people who lived in Bradley all year, I hung out with all the kids who came down the shore for the summer. I met so many kids from North Jersey way back then, who added extra fun to my summers.

As a kid I'll never forget one thing that someone once asked me about Bradley Beach. "So what do you do here in the wintertime?" she asked.

"The same thing that you do," I said. "We have movie theaters, a bowling alley and stores. And we just hang out, too."

They looked at me in amazement.

I now live in Egg Harbor Township, just north of Atlantic City. So I still spend my time going to the beach, even though it is a twelve-mile ride and I can no longer walk four short blocks. I also have a beach house just north of Daytona Beach in Florida.

I guess once you get that sand in your shoes, you can't get rid of it!

COMMENCEMENT

Class of 1966

Bradley Beach Grammar School

Wednesday Evening, June Fifteenth
8:15 o'clock

Ascension Center
Fifth and Fletcher Lake Avenues

Bradley Beach Grammar School
commencement announcement, 1966.
Courtesy of Bryan Feinberg.

SOME OF MY MEMORIES

By Michael P. Schneider

White zinc oxide on my nose and cheeks to prevent my nose from raw peeling. Stomach rash–like burns from riding waves on styrofoam boards all day. Drinking up the ocean while body surfing. Outdoor showers. Sitting on the lifeguard stand eating French fries as the beach clears out. Getting huge splinters in my toes and having them taken out with pins by the lifeguard. Buck-Buck. Running from the boardwalk across the burning beach to the ocean to cool the bottoms of my burning feet. The mystique of "under the boardwalk." The outdoor lobster tank at Mort's Port. Waving to the person who lowers the gate across the street at the train tracks when the train comes. The church bells ringing and waking me up every Sunday morning on LaReine Avenue. The metal walkways over the street drainage swales on each street corner. Being out in the ocean without touching the bottom so that the crabs would not pinch my toes. Picking up cigarette butts and pulling the filters apart so that they would fly away like cotton in the wind. Fudgesicle melting on my stomach in the hot sun on the beach. Jelly doughnuts from the bakery. Swimming "all the way" out to the farthest pole in the surf and swinging

Mort's Port. *Author's collection.*

on the ropes in the water. The "tsunami" wave that came up the beach and got all the blankets soaked. Walking under the boardwalk in the hot daytime in the cool, soft sand. Climbing out to the end of the jetty. Walking on the boardwalk from Bradley Beach to Asbury Park and back. Night dances in the pavilions and outdoor concerts on the lawn of the band shell.

Incident at Bradley Beach

By Dennis Dubin

Everyone has some sort of defining moment in life. For some it might be giving birth; for others it might be a courageous incident during combat. Or it could even be something as simple as that teacher who pats you on the back and fires up that inspiration to go on to medical school. My defining moment occurred at Bradley Beach when I was five.

I can see it now. In 1952 I was skinny and undersized, but I knew the ropes. This was my second summer at Bradley Beach and I was a sophisticated kid. I had learned it all last summer. Also, my preteen sister let me hang around with her and her preteen friends. I was privy to conversations that I was sure no five-year-old on the face of the earth had ever heard. I heard about things that real teenagers did in that perpetual

View of Bradley Beach and Pavilion. *Author's collection.*

twilight under the boardwalk. They even taught me how to get around those aged pith-helmeted guards who checked beach badges. Yes, I was able to climb from the boardwalk to the beach without being noticed.

Every day I went with my mother and my sister to the beach. There were spectacles to behold. Beautiful waves in the ocean that did not intimidate me, as they had at the beginning of the previous summer. Confused people trying to set up clumsy beach chairs. Umbrellas lifted by the wind until they became dangerous projectiles. Lines of old ladies holding onto the ropes in the ocean and yelling "wheeee" every time a wave came. But there was one spectacle that surpassed them all.

Every day at least one lost kid would be held up and dangled by a big whistle-blowing lifeguard. The kid would always be fighting back tears, not because he was lost but because there he was on the lifeguard stand and he had to admit to the whole world that he was dumb enough to get lost. Always, a relieved mother would go running up and grab the lost child in a big hug.

Now, I had freedom. My mother gave me boundaries and they were big. I could roam as much as I wanted, so long as I stayed within those boundaries. Also, I had responsibilities. Sometimes I would be given money and be sent up on the boardwalk to buy sodas, ice cream and those wonderful French fries that came in a brown paper bag. I can still taste them today. They were salty and the grease and the ketchup would soak

through the bag. If I could get them today I'm sure I would lose control and devour them, bag and all.

Sometimes on the boardwalk the elderly people who sat there and read the Yiddish newspapers would stop me. They loved when little kids would say a Yiddish phrase or expression. But then they would bemoan the fact that we could not hold a conversation in that language. I didn't know it then, but my generation was becoming assimilated and the old ones saw that something was being lost.

During the previous summer, trucks had been driven off the boardwalk on huge ramps. The trucks deposited magnificent boulders in the surf. These were the jetties, "the rocks." They were the place to catch a flounder, a blue fish or even the legendary striped bass. When my father would come from Newark for the weekend, he and I would get squid for bait and fish off the rocks. He would talk to the other men fishing and I learned the conversations of men. That summer I could even cast out my own line.

One day I was roaming my area with my friend; I think his name was Eric. He never strayed far from his mother and went back to her, leaving me alone. I kept on walking. I knew I was okay because I stayed in my boundaries. My father was fishing on the rocks and my mother was talking to friends. I kept on walking and walking. And then it happened. I looked around and I did not recognize anything. I kept walking.

I looked at the jetty. I didn't see my father fishing from the rocks. I looked for my sister; I didn't see her. I looked for my mother and her friends sitting on a blanket. I didn't see them. I kept walking, but knew I was going to have to admit to myself the awful truth: I was lost. I was one of those dumb kids who got lost.

How could this happen to me? When you are five, making crucial decisions is something that you are not used to doing. But I knew what I had to do. I stood in front of the lifeguard stand, looked up and said, "Hey, I'm lost. Hold me up so my mother can find me."

This is where it happened—that defining moment. No, I didn't cry. No, I didn't fight back tears. I was a practical kid and I knew that being dangled on a lifeguard stand was a practical solution to my plight. But I was not prepared for what happened next. There, not ten yards from where I was being dangled for public display, was my mother looking right at me. My lord, she was looking right at me! Her friends were poking her and pointing at me and saying, "Rose, Rose!" She was staring right at me. I'll be damned. There I was, a little five-year-old being held up by a big lifeguard furiously blowing his whistle. And my own mother didn't recognize me!

It was humbling. Sometimes it's a big lonely universe, but from less than ten yards away when you are five and your own mother doesn't

Evelyn's restaurant in Belmar. *Author's collection.*

recognize you, it's an existential moment of Jobian proportions. I had hit that quantum jump in maturity when right then and there I realized that the world is strange and that it didn't really revolve around me. Eventually my mother came to her senses, ran over to the lifeguard stand and took me from the lifeguard. She hugged me and said, "I didn't believe it was you; you know too much to get lost."

In Florida thirty-seven years later when Rose died, even in the last stages of Alzheimer's, she recognized my face.

Finest Memories of Bradley Beach

By Arline Cohen

Mrs. Schwartz, originally from Hungary and the wife of a prominent doctor on Park Avenue in New York City, would rent our family a bungalow in Bradley Beach from mid-May into September. When her rooms were all full in all of her homes, she would end up renting her own apartment. Our family lived next to the bowling alley (it is a bingo hall now) and every night our children, Gayle and Larry, would want to go bowling and get a pretzel with mustard before they came in for the night. Bunny Levitt, a basketball player from Chicago, would take all of the kids on the beach and show them how to shoot a basketball and sometimes reward them with comic books and candy.

Mrs. Schwartz once rented an apartment to "Stormy Delray" and a group of talented female impersonators who appeared in Asbury Park. Irv Macartsky, from Newark, would play songs such as "I Love Paris in the Spring Time" on his ukulele. We would all go to Evelyn's in Belmar for great seafood and steamers. My husband Alvin and I even won an award for a cha-cha contest on the boards. Our son Larry was a junior lifeguard on Newark Avenue. And like everybody else, we walked the boards every night and loved it.

THE 1940s

By Stephen Weiss

I spent summers in Bradley from 1944 to 1949, when I was between the ages of six and eleven. Days were spent playing on the beach with friends, splashing around and going to the saltwater pool on occasion.

I had an older sister who, with her friends, got to do stuff that I could not do, such as hanging out at night on "the boards," drinking birch beer and smoking when no one was watching. As I think back, there must have been many nubile "babes" who I would have noticed if I was older. To me, they were just annoying friends of my sister.

It was a very different era. At age nine or ten we went off to the boards after supper on our own and spent our nickels to our hearts' content without our parents worrying too much, if at all. The main concern in those summers was polio.

I vividly recall the headlines in 1945 when the A bomb was dropped on Hiroshima, and the celebration of V-J Day. There were, of course, many sailors around, not to mention the military use of the Berkeley Carteret in Asbury. In fact, when I was seven or eight, my parents brought a fifteen-year-old girl to Bradley to be a nanny at the shore. She met a sailor there and they eloped the next year, when she was sixteen. Shirley is still married to her sailor and is a great-grandmother.

Another memory is the Palace Theatre—nine cents to see a double feature—a great deal on rainy days. I believe there was an ice cream place down the street where we were treated to a "black and white" by whatever adults happened to be with us. Sundays at the St. James or the Lyric Theatres in Asbury were always a treat too. I also recall the heavy chain across the entrance to Ocean Grove on Sundays to prevent traffic.

I vividly recall the navy planes (Grumman Avengers?) patrolling up and down the coast, looking for U-boats, which did lurk out there. From 1944 to 1946 the military presence was large and sticks out in my mind more than anything else.

Again, I'm amazed at how free we were to do our own thing. We shared a summer rental with my aunt and two cousins (husbands showed up on weekends) and every day we got a lunch bag and a caution to "be careful" at the beach. Big sisters and brothers were told to watch us younger ones, but hardly ever did. My sister never knew that I dumped the hardboiled eggs my mother made for me, since they were never completely cooked. As for the rest, I probably ate as much sand as food anyway.

I still recall street names—Brinley, Evergreen, LaReine, Main, Ocean…

What a great way to spend a summer!

ODE TO A KNISH

By Lori Lafer Litel

1972 was the year
Oh to my eye it brings a tear
Of course it could only be one thing
The Second Avenue knish, does a bell ring?

To the snack stand by the boards
Through the hot sand I would roar
The knish, the knish I would say
With a Coke on the side, how it made my day!

Deep fried and sliced in quarters
They must have filled a thousand orders
For the only way to describe the knish
Is "a little piece of heaven on a dish."

GOT YOUR BADGE?

By Sol Seigel

I was a beach badge checker in Bradley Beach. Six days a week in the summer I would get up at 7:30 a.m., shower, read the paper and eat breakfast with my wife. She packed my lunch and gave me a thermos and sent me on my way over to the boardwalk. My job was to check badges, the admittance to the beach. There were male and female badges back then and junior badges for the younger teens, all made of plastic. They were about twenty-six dollars for the season back then. Some folks came

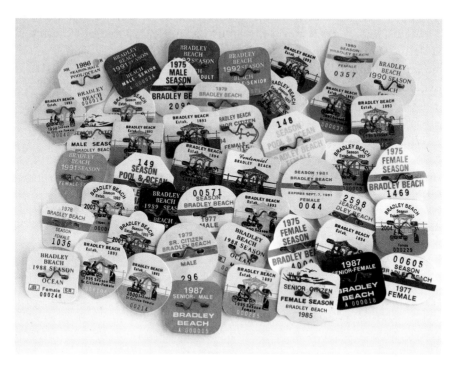

Collection of beach badges. *Photo by Matt Johnson.*

for the month and had to get a badge for July or August. There were also day badges. They were round metal circles with numbers and a pin. The season and monthly badges were different shapes and colors every year and some folks would even collect them year after year for their memories.

At that time, I was a badge checker mostly to get out of the house, be out in the fresh air, see people and get a few extra dollars after my real working years were over. I had to be at my post by 9:00 a.m. and stay until 5:00 p.m. The other fellows and I would give each other a break now and then and covered for each other when we took our lunch. We wore lightweight blue uniforms and a pith helmet to keep us cool. We all sat under umbrellas. Without them, all day in the sun for six days straight could do us in.

When it was time for our lunch I would walk over to the pavilion and sit in the shade, where there was a breeze. My wife usually packed me a salami sandwich with mustard on a roll or a turkey or tuna sandwich. I would either have coffee in my thermos or a cold drink if it was very hot. On

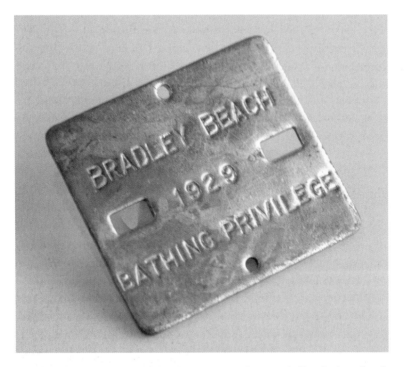

First beach badge in the United States, 1929. *Courtesy of Alan Gordon, photo by Matt Johnson.*

very cool, damp days I even had some chicken or vegetable soup. The folks around were nice and if we needed anything we could always find someone to get something for us at one of the boardwalk stands.

There were times when a few people (mostly boys) would try to sneak on the beach or jump over the railing. Sometimes I blew my whistle and made a fuss and the cops would come. Other times I would make believe I didn't see them, as I lived through the spirit of the young. Sometimes the boys would run away as fast as cheetahs.

Usually, I would see the same faces every day during the week. On weekends there were the day-trippers and all the fathers who would join their families for the weekend. The badge money mostly went to pay for the lifeguards, equipment and, of course, my job. Some regulars would forget their badges. You never knew if they lent their badge to someone else or if they just left it on the counter or in another beach bag at home. I usually let them go on the beach, reluctantly though, as I didn't want them to get caught down at the beach if anyone was checking.

There were times when folks would ask me if they could just go on for a minute to find a friend. I would watch them and most of them only stayed for a minute. Others beat the system and snuck away, out of my view.

All in all, I loved the beach, the people and the feeling of getting up every day and being part of the activity of the boardwalk at Bradley Beach. Thinking about it again reminds me of the smell of the salt air, and the good old days when families were families and life was good.

Note: Bradley Beach was the first beach community in the United States to have beach badges. The first year was 1929 and they were made of metal.

My Mom, the Badge Lady

By David Schechner

My mom, Mrs. Selma Sophia Schwarz Schechner, lived in Bradley Beach in the same house at 309 Ocean Avenue for longer than most anyone ever lived in Bradley Beach. My grandfather, Samuel Schwarz, of Schwarz Drugs on Main Street, built the house in 1913–14. My mom had every beach badge (female version) ever issued by Bradley Beach. She delighted in wearing her hat and bag with all of the badges scattered all over them. She never made the current badge visible to the beach guards for admittance to the beach; however, they all knew her and didn't have the guts to ask her for the correct one.

Every so often, the Bradley Beach Historical Society asks for the bag and hat for various displays. My mom was some lady and she had some collection of badges too!

Bradley Beach Mayor Leonard Riley honors eighty-one-year-old Selma Schechner with a special citation. Ms. Schechner is wearing a hat and beach bag covered with beach badges from the last forty years. *Photo by Bill Denver, August 1987. Reprinted with permission, courtesy* Asbury Park Press, *a Gannett Co. newspaper.*

WHY BRUCE?

By Richard Schwartz

What sets him apart? "Yeah, I've heard him. He's all right, but I don't see what all the fuss is about." This sentiment has usually been expressed by someone who has never seen him live. I could have said that before I saw him in 1979 at the "No Nukes" tour in Madison Square Garden. Most performers would like to have the crowd at the end of the show the way he had us on the first song (twenty thousand people singing "Prove It All Night"). Other shows during his career had him playing for more than four hours with four encores!

It was another ten years before I saw him again with the E Street Band (also at the Garden). Oddly enough, another decade went by until I came back to his "church" to hear the minister of rock 'n' roll in 1999. Recently, my wife Donna and I followed him around on his Florida leg of the 2000 tour (fourteenth, sixth and third rows!). So why is there such a religious devotion among his fans? Well, for one, as a live performer there is no equal. At fifty-plus years old he's still a rocker, baby, he's a rocker!

While there is a certain connection or bond that we share (Bruce and I; yes I have met him—he wouldn't remember but I did shake his hand as he came off stage in a small venue in Rumson, New Jersey). The bond is that we come from the same towns growing up. "That's me he's singing about" is a common opinion for many when discussing his songs. The truth is that he comes from your town, too. He was "Born in the USA" and "The River" in "Darlington County" is any river in any county…get the picture?

As a young songwriter and rebellious rocker, he wrote songs as if he was "Born to Run" (consistently ranked in the top three by many—VH1, MTV, WNEW—as the greatest rock 'n' roll song). There's a recurring theme of the adolescent runaway from "Thunder Roads" and the "Badlands." Who among us didn't want to escape "My Hometown"? Like when we first got our licenses and a whole "new world" opened up to us. To go out for a ride and never go back; everyone has had an unquenchable thirst and a "Hungry Heart" at one time or another. The "Glory Days" of high school may now be more glossed over when we look back. The bad times may not have been so bad and the good times now seem great. Yet there was the "Brilliant Disguise" of teenage awkwardness trying to be "cool" while "Dancing in the Dark" with "Bobby Jean." It was that rock 'n' roll youth that he sung about—"we had rock 'n' roll music blasting from the T-Top!" Each one of us has had that no retreat, "No Surrender" attitude at one time or another. Bruce wrote about all the things that we experienced while "Growing Up." Not just one song but his whole "body of work suggests the escape to community to the path of redemption."

As he got older and more mature in his themes he was beginning to search for more. No longer content to just run from the "Jungle Land," he longed to find the intimacy of relationships and his songwriting showed it. He can still be found trying to escape "Murder Incorporated" (where your chances on the street are less than zero) by catching a "Downbound Train." Yet he then began talking of the vulnerability of falling for that special someone where it's just another "Roll of the Dice" as you enter the "Tunnel of Love," and as "you're walking and a hand should slip free, I'll wait for you, should I fall behind wait for me." I hope that you can remember and always still think that "She's the One" (or he). Get a chance to see him.

The promise that Bruce has always delivered on is that he cannot promise you everlasting life, but he can promise you life right now. That message is that "it ain't no sin to be glad you're alive!"

Splinters

By Elenore G. Peckerman and Elsa L. Cook

Our grandfather always had a needle on the underside of his jacket lapel. As children, of course, we were always barefoot, so we were always getting splinters from running on the boardwalk. No one ever went to a parent—that's what "Poppa" did. Out came the needle…out came the splinter…on the face came the kisses!

Bradley Beach Forever Etched in My Memory

By Karen Usatine

Life changed forever after the freedom of
adolescence in Bradley Beach, New Jersey.
Growing up near the Hudson in New York I
loved open skies and wide water.
Summers at the shore: the beach, boardwalk,
rock and roll in the '60s and '70s.
We felt friendships forged were for life; we were
intense, passionate and hopeful.

Growing up near the Hudson in New York
I loved open skies and wide water.
Ocean Avenue rooming houses, shared kitchens,

bathrooms, outdoor showers.
We felt friendships forged were for life; we
were intense, passionate and hopeful.
Older and wiser now, I know friendships rarely
last forever, regardless of intention.

Asbury Park, Bradley Beach, Belmar, Ocean
Grove, forever etched in my memory.
The salt air, waves on white sand, rocky
jetties and blue skies timelessly imprinted.
My Jewish/Italian family, Ma and Tony
took us there, where we made a second home.
I visited the shore often after 1976, my last
full summer before college.

I live near the coast still, near San Francisco,
between the Bay and the ocean.
I harbor no adolescent hope, but timeless
and passionate, the ocean calls me still.
Living within an hour of the coast is an
emotional requirement for my life.
Early friendships faded for decades,
revived by a reunion and strong bonds.

I harbor no adolescent hope, but timeless
and passionate, the ocean calls me still.
I flew cross-country full of expectations
from those early years, innocence lost.
Early friendships faded for decades,
revived by a reunion and strong bonds.
Life changed forever after the freedom
of adolescence in Bradley Beach, New Jersey.

Trip to the Beach

By Ronnie Bornstein-Walerzak

One of the many thoughts I have had recently about my youthful experiences going to the beach, specifically Bradley Beach, is how much has changed over the years. Not only the size of the beach itself, but how simple going to the beach used to be. I'd grab my blanket, transistor radio, lotion for a

deep tan, a few dollars that would last all day and away I'd go. I could get a burger and Coke for pennies at Mike & Lou's. Water didn't come in bottles unless you put it there, so the fountain on the boardwalk was just perfect. We entertained ourselves listening to music or riding the waves.

Now we need the best telescope chair imaginable; wheels are a plus. The umbrella, the sun block, the cooler, the sand toys, the beach reading materials, the blanket, plenty of quarters to feed the meters, plenty of money to feed the kids because the stand food is better than mom's, the iPod, the TV with the five-inch screen, the cell phone, the Game Boy, insect repellent, baby powder to get the sand off, the water bottle with the fan attached because I couldn't actually step into that rough water, the raft, the boogie boards, the goggles, the ear plugs, the water jug, the sport drinks for the kids, of course my favorite designer coffee in a thirty-six-ounce container and then at some point before leaving the beach I'd have to call my chiropractor for an appointment because for some reason my back and neck were out. Did I mention that before I even stepped onto the sand, we had to drive around the block fifteen times before we could get a spot to park?

Remember how simple life used to be?

My Mile of America

By Bette Blum

My mile of America
From lake to shining lake,
Where young and old find heaven
And life's not hard to take

Mink stoles and skimpy halter tops
Once seen upon the boards
Dances, concerts and miniature golf we played
Were fun we could afford

Pinball, skeeball, Pokerino
And the charm machine you'd feed
Saving points all summer long
For something you don't need!

Fries in little paper bags
Salt and ketchup poured on top,

Sam Ballen as a child. *Author's collection.*

Using skinny wooden two-pronged forks
Before our ten-cent ice cream pop

Hot dogs prepared with all the works
The snow cones in a mound
Potato knishes, subs or burgers
The best taffy to be found

My mile of America
With flags on every street,
Open porches, outside showers
That welcome sandy feet

We'd beg to go on kiddie rides
Red fire trucks with bells go round
A silver slide right on the beach
Our blue shovels in the ground

Sea Glass and Driftwood

Lifeguards with those outrageous tans
A child they're quick to save
Seagulls feed off jetty's peak
Then dive into a wave

While beach guards checked the badges
Boys would check out girls they saw
And the one-way streets at summertime
Have been a needed law

My mile of America
Where friends are friends for life, you know
No matter where you came from
No matter where you go

A sky with birds and kites and rainbows
Small planes with flowing signs
Yards of oak trees, lilies, honeysuckle
And gold scattered dandelions

Fireflies, fireworks, volunteer firemen
We all cherish more and more
A busy train station and a Main Street
With an Army Navy store

The bakery's fresh aroma
Of a tempting sweet surprise
Archie comic books at newsstands
Vic's hot tomato pies

My mile of America
A parade for this and that
Where life is sweet and simple
And home is where it's at!

Dads would take us fishing
In the ocean or on the pier
As moms would fill our every need
And cherish us so dear

Our grandparents played cards late at night
My grandpa had the kings!
The coffee cake was fresh and warm
The winner proudly sings

Always worth the traffic
Exit off 100B
To find a piece of happiness
A place we'd yearn to be

My mile of America
Who could ask for more?
Bradley Beach, the town I love
Right down the Jersey Shore!

Part Four:

The Reunion

Reprinted from

The New York Times

Originally published Sunday, May 23, 2004

BLANKETS, ICES AND SHAVING CREAM

By Bette Blum

The early '70s were a time of sex, drugs, peace, love and good old rock 'n' roll. For the fortunate bunch of teenagers that went to Bradley Beach, New Jersey, in the summer it was a time of freedom, friends and growing up.

Located north of Point Pleasant and Belmar and south of Asbury Park, right between Sylvan Lake and Fletcher Lake, Bradley Beach was always a family town by the sea, booming from Memorial Day to Labor Day.

We would come out of our shells like turtles late in May and hope to begin the summer as early as Memorial Day. We would even gather in winter coats to find a familiar beach friend on the boardwalk, as we didn't want to miss a minute of the summer.

Some of us lived in Bradley Beach or nearby towns all year round, but most of us came from not-so-faraway towns such as Clark, Westfield, Springfield,

The Reunion

Hillside, Union, West Orange, Millburn, Short Hills, South Orange, Maplewood, Livingston, Cranford, Linden, Paramus, Passaic and Fairlawn. Others were from Brooklyn and other parts of New York. Some families had houses and bungalows or grandparents that did. Other families would rent houses or apartments for the summer. There were also some teenagers who came on their own without their families and stayed in rooming houses like the Janet House on Ocean Park Boulevard and the North Lodge on LaReine Avenue to "experience" the Jersey Shore in the summer.

My favorite place is still my mom's bungalow on Madison Avenue, which has been in the family for over sixty-five years. It is still fully equipped with mismatched dishes, a front porch with rocking chairs and a fabulous outside shower.

During the day we would meet on Brinley Avenue beach and connect one blanket to the next and "hang" all day making friends, playing football, riding waves, sitting on tire tubes for hours, surfing, flirting and having fun.

Some of Bradley's best still remains, such as the beautiful expanded beach, restaurants such as Vic's and Piancone's, a nice miniature golf course and even some of the same lifeguards!

A lot has come and gone in the last thirty years. In Bradley there were the landmark LaReine-Bradley Hotels, with restaurants like the Bunny Hop and Mike & Lou's. The dance pavilions on Newark Avenue and LaReine are gone but still hold a lot of memories. Our dads always went to Freedman's bakery for Sunday morning danishes. The Criterion Candy story was even in Bradley for a while with saltwater taffy, candy apples, fudge and all sorts of chocolate delights. There were kiddie rides on Park Place and even a pool. Sadly missed are the Penny Arcades. There was one on Newark Avenue, but the teenagers would meet at the larger one on LaReine Avenue where they had skeeball, Pokerino, a fabulous nickel charm machine and, most important, the pinball machines. We would spend hours and hours each night trying to beat each other and win free games that were only a dime at the time or a quarter for three games. We would also win points for some of the games and save them up to get one silly tchotchke at the end of the summer.

We would spend time in Bradley at Joe's Pizza on Newark Avenue, where the Italian ices were fresh and homemade. Virgil's was not only the place to get the morning paper but also a fresh kaiser roll and your favorite candy. We would also frequent Schneider's on Main Street and Greg's Nosheray on Ocean Avenue to cure the munchies. Some of us even tried to get jobs in the summer in Bradley. I worked at S & S Market on Newark Avenue selling fruits and vegetables to every parent and grandparent around. It was great, as I worked until 1:00 p.m. and still got to the beach every day.

From the beach to the boardwalk at night…we couldn't get enough of each other.

We also spent a lot of time in nearby Asbury Park, where we were allowed to walk on the boardwalk to concerts to see Elton John, Humble Pie, Cheech and Chong, Chicago, Sha-Na-Na, Three Dog Night and Emerson, Lake and Palmer. We were even the first to see Bruce Springsteen at the Pony. There were also the Palace Amusements, rides on the boardwalk, the famous Swan Ride, two miniature golf courses and treats like Kohr's custard, funnel cakes, great pizza and cotton candy along the boards.

We would cry on Labor Day, after our annual shaving cream fights, as we knew it was back to school and the end of another wonderful summer. Some of us would gather for parties and sweet sixteens during the winter and try to visit summer friends when we could.

They were good times; they were the best times. Now it is time for a reunion to reminisce, reconnect and celebrate the most incredible times of our lives.

Living in south Florida, I began looking for old friends through Classmates. com, Google.com and even making phone calls and sending letters to my old friends' mothers, a reliable source that always came through with a connection. In the beginning I anticipated to find about forty or so folks; I found over eighty, and now several of us plan to get together in July! Each time I connected with a "Bradley Beach friend" it made my day, like finding a pot of gold. I even yelled out in joy. I found Steven, Lori, Michael, Amy, Jeffrey, Michelle or Larry!

Sitting all day in the sun on the beach with friends and doing who knows what at night gave us freedom, friendship and character. Now we are doctors, nurses, attorneys, accountants, engineers, marketing and retail executives, CFOs, CEOs and a lot of Indian chiefs, not to mention some really special parents too. There is a lot to be said about all that salt air!

At least three couples met and married, several named their sons Bradley and one even named their daughter Brinley after Brinley Avenue beach, where we sat every day.

Now we are in at least eleven states and three countries. Almost thirty years have passed and we missed each other more than we ever knew. We made special "Bradley Beach friends" in our early teens that we all cherish today. I just can't wait to give each of my "Bradley Beach friends" a big hug (and perhaps a big kiss too)!

We may not have Bradley Beach sand in our shoes, but it is certainly in our hearts.

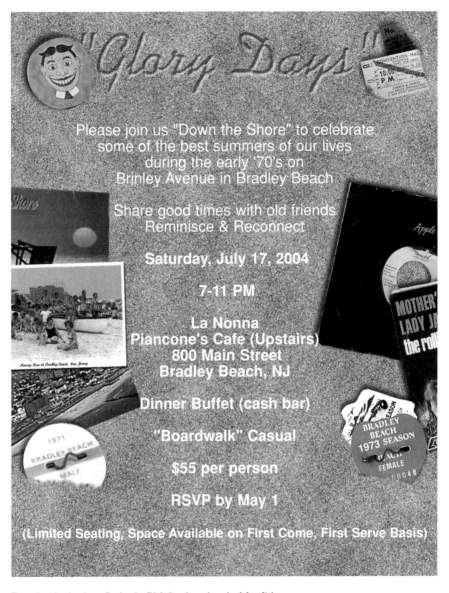

Reunion invitation. *Design by Rick Sparkes, photo by Matt Johnson.*

Back to the Beach

By Kitty Bean Yancey

Bette Blum and Marc Schwartz are chuckling over the black-and-white photo of them as formally dressed four-year-olds coaxed by their moms to partner up at a dance in the Newark Avenue Pavilion.

In childhood summers, they—and the five dozen other forty- and fifty-somethings reunited here tonight—were inseparable. Their teen days were spent in a group on the beach, their nights hanging out at the boardwalk or Penny Arcades or strolling to Asbury Park to hear a then-obscure rocker named Bruce Springsteen. It was at Bradley Beach that many savored their first kiss, first love, maybe even a first, forbidden sip of Boone's Farm apple wine. Tears flowed after the Labor Day shaving cream fight, because that meant it was time to go home.

Like many in the party room of Piancone's restaurant on a recent Saturday, Schwartz and Blum, now forty-seven, haven't seen each other for three decades. Dressed as requested in "boardwalk casual," the group is here at Blum's instigation to reconnect and reminisce about their glory days, the best summers of their lives.

"You went to the shore until Labor Day, and you never wanted to go home," says Beth Palent Saper, who flew in from Denver for the reunion.

Kids from New Jersey and New York would meet and meld. They'd leave unlocked cottages in the morning and not be heard from until supper. They'd roam freely at night. "Would I let my kid do that today? No, never!" Saper says. It was a different world then.

Safety and innocence. Sunny days of endless play. Vacations at a serene spot returned to year after year were summer magic—an unforgettable, formative idyll.

Many adults, if we're fortunate, have a place like Bradley Beach. Maybe it's a shore town on Cape Cod or the Outer Banks, or a lake in the Ozarks. It's a place whose name alone conjures up childhood fun. And while our photos may be fading, those memories never will.

That's especially true for these Bradley Beachers, a tightknit group who came of age in the 1970s and for whom this mile-square beach town of closely spaced, modest frame cottages holds enduring enchantment. Many have grandparents and parents who vacationed at this family resort about sixty miles south of New York City and passed on the Bradley Beach rituals.

Among them were hours in search of a mahogany tan in pre-sunscreen days. The novelty of an outdoor shower. The excitement when Dad stepped off the 6:00 p.m. Friday train, after toiling all week. The joy of late nights

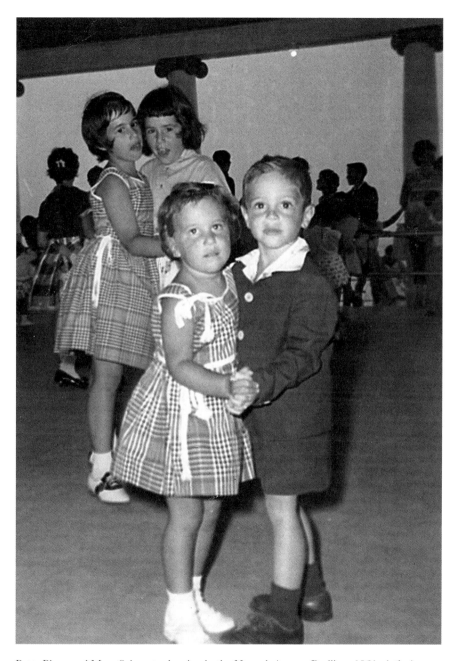

Bette Blum and Marc Schwartz dancing in the Newark Avenue Pavilion, 1961. *Author's collection.*

bonding with a gang of friends without getting mugged, pregnant or arrested.

"We're here to celebrate the best days, the best summers. A toast to the parents and grandparents who brought us here and made us the luckiest kids in the world," Blum, a frosted-blonde ringer for *Sopranos* actress Edie Falco, tells the crowd. She has finally persuaded them to stop yakking and looking at one another's old photo albums and to sit down to chicken parmigiana, eggplant and penne vodka.

Reunion attendees have come from seven states. Three couples are now married. Two even named sons Bradley. Sandy and Leslie Kaston began dating here at age fourteen and never went out with anyone else. They named their daughter Brinley after the Brinley Avenue stretch of Bradley Beach, where they courted and where he proposed a quarter-century ago. Now twelve, the girl shyly edges in to peek at the partiers.

Meanwhile, reunited friends clutch cosmopolitans, margaritas and beers and whoop when they see a special pal.

"Oh, my God, Richie!" yells Skipp Silverman, a teddy-bearish guy in a tropical print shirt. If Bradley Beach were a high school, he'd be voted most outgoing. He envelops Richard Usatine, a lean forty-seven-year-old with a gentle smile, in a hug.

Usatine was the beach brain, the guy who would tote serious books to the sand, and a dictionary too. He's now a doctor and professor of family medicine at the University of Texas–San Antonio.

Silverman, who's weathering a divorce, has moved back to the Jersey Shore. "I'm getting back in touch with my inner self," he says.

Life isn't a beach party, he and other reunion-goers have learned. They've dealt with loss. Disillusion. Disappointment. And maybe that's why those lazy days of summer take on a rosier tint with each advancing year. Just ask any spouse of a true-blue Bradley Beacher.

Verna Lewis-Stein of South Brunswick, New Jersey, says her husband, Fred Stein, talks about Bradley Beach "like it was nirvana. All of us who married into the Stein family know we have to make pilgrimages to Bradley Beach, hear the stories."

And everyone here has one.

Mark Jacobs recalls being given the freedom to stay solo in a boardinghouse as a teen. He had a summer job. The worst thing he and pals did was get someone to buy them vodka, he says.

Frances Reiter met her first boyfriend here. He was an Asbury Park resident. She was thirteen; he was sixteen. "We held hands, kissed under the boardwalk, hung out at the Penny Arcade. He gave me his ring. We dated the summer, which is a lifetime when you're thirteen."

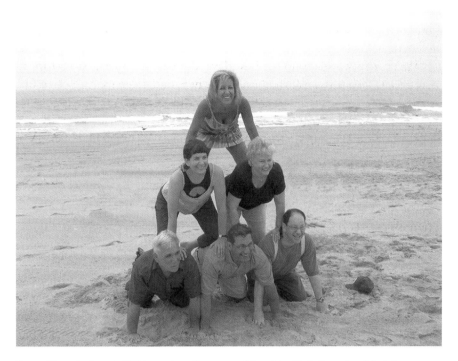

Pyramid on the beach, 2004 reunion. *Bottom row, left to right*: Rich Consales, Mark Levy, Larry Zeller; *middle row, left to right*: Karen Usatine, Stacy Strulowitz Zeller; *top row*: Bette Blum. *Courtesy of Richard and Karen Usatine.*

For Amy Cuttler Frankel, Bradley Beach stays were times of learning "all about life and love and relationships," and bonding with a group of really nice people. Says Jacobs, echoing others here, "I didn't go to my high school reunion. They were the people you were with, but these were the people I *chose* to be with."

Spouses and kids of Bradley Beachers sometimes don't get it, says Michelle Kupperman Ott. "I took my family here two years ago. I said, 'Isn't it beautiful?' They said, 'Nooo…' They didn't see it. I was seeing the town through the glasses of my wonderful childhood. It's funky. Even a little dumpy."

Blum, an advertising executive living in Deerfield Beach, Florida, is so passionate about Bradley Beach that she decided to get her friends together again. She wrote a nostalgic essay (now on cmyparty.com) and tracked pals on Classmates.com and Google.com. And she worked via that age-old telegraph system: friends' mothers.

The morning after the reunion—which lasts until Piancone's bar closes at 2:00 a.m.—she leads a tour of *her* Bradley Beach.

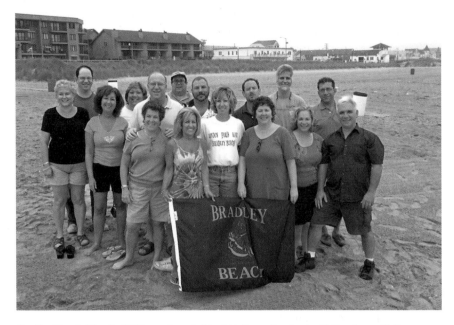

Bradley Beach friends, 2004 reunion. *Left to right*: Stacy Strulowitz Zeller, Larry Zeller, Sherri Mitzmacher, Andrea Schulman Paris, Leslie Raff Kaston, Sandy Kaston, Mark Jacobs, Bette Blum, Skipp Silverman, Cindy Mitzmacher, Ron Reich, Michelle Kupperman Ott, Chris Ott, Lori Lafer Litel, Mark Levy, Rich Consales. *Photo by Leo Sorel.*

The starting point is mom Gladys Blum's gray summer bungalow on Madison Avenue, with what Bette calls "a refrigerator older than me" and mismatched dishes. Gladys, with perfectly applied lipstick, smiles amiably from her pink rocker and remembers the days when basketball-bouncing boys would come down the street. "Sometimes they picked Bette up at 4:00 a.m. to see the sunrise. There'd be a group of twenty kids, and none of the kids ever got into any trouble."

Bette interjects, "I can't say we never did anything wrong. But we never got in trouble."

It's nearly 11:00 a.m., and time to meet Bette's old friends at the beach. En route, she points out where the LaReine Avenue Penny Arcade used to be. It's gone, as is the pavilion where she and Schwartz danced. But the miniature golf course is still here.

Some reunion-goers meet at a gazebo on the boardwalk, which isn't the old boardwalk they knew. It's a kind of brick now—no more splinters to lodge in summer-toughened bare feet. And you can't slip under it anymore, putting an end to the mating dance that the male reunion attendees describe in loving detail: Meet a girl you like. Walk by the shore. Hold hands. Stop for

a kiss. Suggest going to a more private place, then retreat to a spot under the boardwalk and hope another couple hasn't gotten there first.

After more hugs and photo ops, the reunion group straggles down to the beach. They head for their traditional spot: halfway to the water, near the lifeguard chair. The hardy group recreates a beach pyramid like ones they formed when they were young and limber.

Sandy and Leslie Kaston, still radiating that in-love glow, say they wish daughter Brinley could forge the kind of beach-blanket friendships that will last forever.

Nowadays you won't see a giant pack of summer boys and girls together from sun-up to sunset, they say. But there's a chance the torch will pass to the next generation.

If she ever gets married, Brinley told them, she might like to do it in the gazebo at the end of Brinley Avenue, to the sound of waves lapping onto Bradley Beach.

From *USA TODAY*, a division of Gannett Co., Inc., Monday, August 2, 2004. Reprinted with permission.

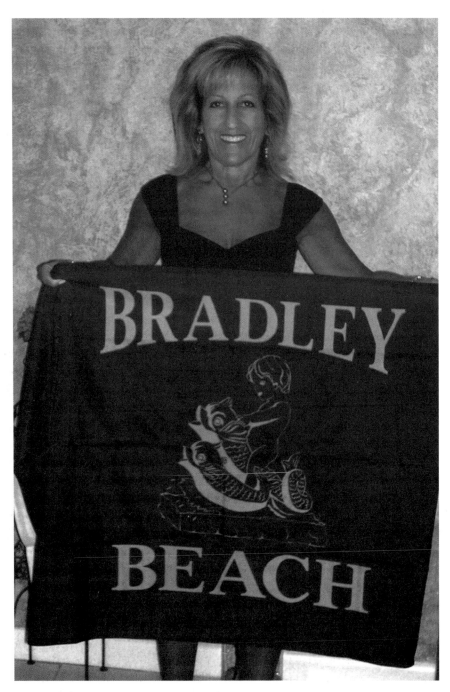

Photo by Cindy Mitzmacher.

About the Author

Born in Newark, New Jersey, and raised in nearby Clark, Bette Blum discovered the treasures of Bradley Beach at an early age. Before she could even walk, she could be found enjoying the soft sands near her family's bungalow on Madison Avenue. Bette not only "grew up" in Bradley Beach, but grew to love this charming seaside town along the Jersey Shore.

After graduating from the University of Bridgeport, she embarked on a career in advertising with NW Ayer, one of New York's most prestigious firms. Even then, Bradley Beach provided welcome relief from her crazy and hectic days working in the city. She eventually moved to south Florida, where she continued her advertising career with several top agencies and corporations, and in 1999 she was awarded *Media Week*'s National All-Star Award for Newspapers. Despite Florida's abundance of sun, sea and sand, Bette would return to Bradley Beach each summer to reconnect with family and friends.

In 2004, Bette organized a reunion of sixty Bradley Beach friends who all spent time together as teenagers in the early 1970s. The event received national attention in *USA TODAY*, and Bette wrote a story about those "glory days" that was published in both the *New York Times* and the *Asbury Park Press*. The reunion helped recall wonderful memories of carefree days and great friends, and spawned the idea for this book, *Bradley Beach Treasures*. In many ways, the reunion has not ended, as Bette has been busy collecting stories, poems, anecdotes and memories from her friends, neighbors and their families for inclusion in this book.

Today, Bette lives in Deerfield Beach, Florida, five miles from the ocean, but her heart has never been closer to Bradley Beach.

Please visit us at
www.historypress.net